IMAGES
of America

AUGUSTA
SURVIVING DISASTER

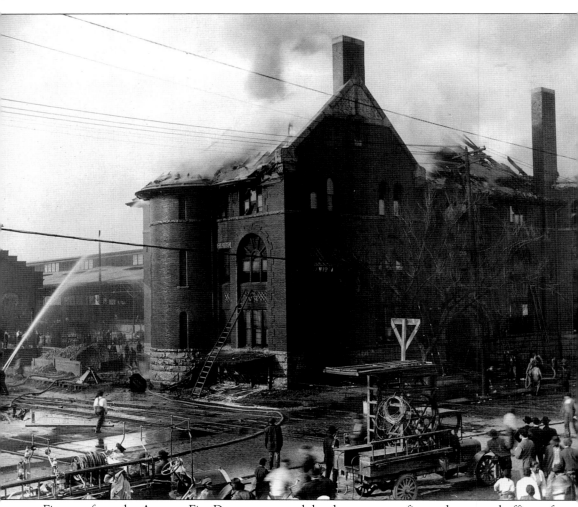

Firemen from the Augusta Fire Department work hard to put out a fire at the general offices of the Georgia Railroad. This fire broke out on January 20, 1920. Firemen battled the flames for three hours. Supposedly a cigarette started the fire that gutted the building. The general office was built in 1890 following a fire that destroyed the old depot and office building. The old records in the building, located at the corner of Eighth Street, fed the fire.

IMAGES
of America

AUGUSTA
SURVIVING DISASTER

Misty A. Tilson

ARCADIA
PUBLISHING

Published by Arcadia Publishing
Charleston SC, Chicago IL, Portsmouth NH, San Francisco CA

Printed in the United States of America

Library of Congress Catalog Card Number: 2002107402

For all general information contact Arcadia Publishing at:
Telephone 843-853-2070
Fax 843-853-0044
E-Mail sales@arcadiapublishing.com
For customer service and orders:
Toll-Free 1-888-313-2665

Visit us on the Internet at www.arcadiapublishing.com

I would like to dedicate this book to my parents, Edward and Barbara Tilson, who have continually supported me in all my endeavors. Thank you both so much.

CONTENTS

ACKNOWLEDGMENTS

I owe an enormous amount of gratitude to Joseph M. Lee III. Without him, this project would have never seen completion. Not only did Mr. Lee provide additional images, he graciously helped me with identification and allowed access to his own research notes. I would also like to thank Gordon Blaker, who presented me with the opportunity to take on this project and offered me guidance along the way. I want to thank Laura Pasch for graciously acting as proofreader on this endeavor. Finally, I would like to thank my coworkers at the Augusta Museum of History for their support and encouraging words.

INTRODUCTION

The "Garden City," though beautiful, has a long and painful history when it comes to devastating events. Many years of its existence have been punctuated by disasters, both natural and manmade. With the advent of photography, these images have become valuable documentation to the disastrous events. They not only document the disasters themselves; they also provide visual evidence of the changes the events have wrought on the landscape of Augusta. These photographs also act as testimonies to the resiliency of the human spirit. The citizens of Augusta have pulled themselves up by their bootstraps repeatedly to overcome obstacles and setbacks.

This volume contains information on the disasters that affected downtown Augusta and its surrounding area over a 50-year period. The majority of the photographs and postcards within this volume are from the collection of the Augusta Museum of History. Joseph M. Lee III, a native Augustan, generously loaned the remaining images. Mr. Lee has an enthusiastic interest in the history of his hometown.

Three major elements—wind, water, and fire—have contributed to the changes thrust upon the downtown area. A major tornado hit Augusta in the early hours of February 8, 1878. The tornado traveled southeast to northeast, destroying everything in its path. The cyclone barely missed the Academy of Richmond County and then cut a path from Ellis Street to Broad Street. The Lower Market, located at the intersection of Fifth and Broad Streets, was destroyed, leaving only a pillar and the privy standing. The pillar was moved to the corner of Fifth and Broad Street when the market was rebuilt in late 1878. It was often referred to as the "Haunted Pillar;" many believe any who touch it will be cursed. The market was rebuilt because many of the merchants thought they could not make a living without it; it lasted on this site until 1892 when it was torn down.

Augusta has a natural advantage in commerce and agriculture in the fact that it sits on the banks of the Savannah River. This would soon prove to be a liability. Since its foundation, destructive floods have ravaged the city at regular intervals. The first truly devastating flood occurred in 1848. Another followed in 1868, another in 1888, and the most destructive flood happened in 1908. The 1908 flood spurred city officials to begin serious planning for a levee to block the river. In March 1909, the city council created the Canal and River Commission. Concrete plans were made and a contract for the erection of the levee was begun in sections in the fall of 1912. In the early stages, a couple of minor floods in 1912 and 1913 tested the durability of the levee walls. Money for the levee ran short in 1914. Special bonds were sold to

raise funds and the levee was completed in 1916 except for a few final changes, which came in 1919 at the cost of $2,119,800. The levee walls held, but another flood hit the city in 1929. In 1926, the Savannah River Power Co. applied to the Federal Power Commission to build a dam at Clarks Hill. The project was shelved for almost 30 years due to cost. The dam reduced the possibility of any heavy rise in the river level.

The city of Augusta has also suffered more than its fare share of fires, all of which were due to human error. In 1899, the same block of Broad Street was struck by fire twice, once in June and then again in December. On June 7, 1899, a fire began in a drugstore operated by Davenport and Phinizy when resin was melted and mixed with turpentine and possibly spilled on the floor. Winds carried embers from the fire down Reynolds Street. Later that same year on December 10, a fire broke out at 3 a.m. in the J.B. White Building. The December fire was much worse than the one in June. The most well-known disaster in the city's history was the Great Fire of 1916, which began in the Dyer Building at Eighth and Broad Streets. Reportedly, a clothing iron left unattended in a tailor's shop started the fire. The fire spread quickly due to high winds and the city's many wooden structures. This fire destroyed 25 blocks of downtown Augusta. Another minor fire followed in November of 1921. Once again, the origin of the fire was at the corner of Eighth and Broad Streets. Fortunately, this time the fire was under control in less than three hours.

Although uncommon occurrences, even snow and ice have caused difficulty. In both 1886 and 1917, temperatures reached below zero. During the 1886 episode, the Savannah River actually froze over. In 1917, an inch of snow blanketed the city. The ice and snow themselves were not the problem—the problem was the arctic-like temperatures. Many people went without heat and proper clothing.

Throughout many of these disasters, the city and the citizens responded immediately with aid and manpower for cleanup. The field of debris left by the tornado was 200 feet wide. Much of the debris was removed during the day. After the December 1899 fire, the citizens of Augusta took the opportunity to improve the city and modernize it while they rebuilt. During the 1908 flood, local women gathered warm clothing and dry bedding for the more heavily affected districts. The city council appropriated $5,000 for a relief fund. In view of the conditions, Councilman Branch made a motion that the city revoke laws prohibiting work on Sunday for the duration of the cleanup effort. After each flood, the citizens raised money and lent a hand to help those who had lost their possessions and to clean up the city streets.

One

TORNADO OF 1878

The tornado hit in the early morning hours of February 8, 1878. It traveled from the southwest to the northeast and cut a path of debris that measured 200 feet wide. The cyclone twisted through Augusta, barely missing the Academy of Richmond County. The Lower Market was demolished leaving only a pillar, which was moved to the corner of Broad and Fifth (Centre) Streets. Pelot and Cole, Augusta photographers, placed an ad in the newspaper telling readers that they had made some excellent photographs of several of the principal points of interest that had been damaged.

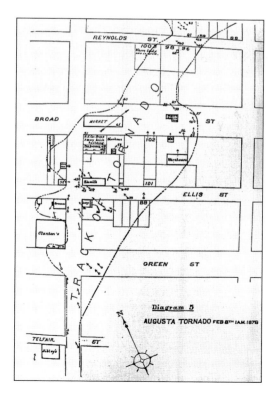

The Army Signal Corps had a weather station located at the corner of Broad Street and McIntosh (Seventh) Street. The station monitored all weather activity, including the 1878 tornado. This map was included in the official report of the chief signal-officer, published by the war department in 1878. Sgt. H.R. Stockman prepared the report. The map shows the track of the tornado as it made its way down Fifth Street. The Lower Market and Clanton House both appear on this map.

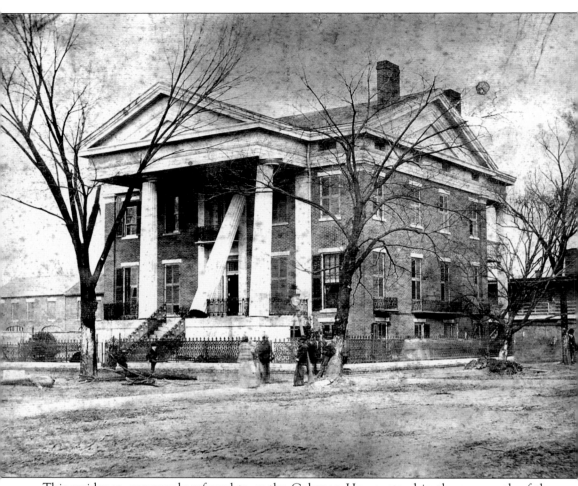

This residence, commonly referred to as the Coleman House, stood in the same path of the tornado as the Lower Market. The house, located at the corner of Greene and Fifth Streets, suffered minor damage during the storm. The February 9 *Augusta Chronicle* reported that, "At the northwest corner of Greene and Centre Streets, [the tornado] struck Mrs. Clanton's residence, blew down a part of the iron fence and tore out two of the immense pillars in front of the house and loosened the others." In the early 1900s, this was the home of Dr. Thomas D. Coleman, a physician and surgeon. The building later housed the Richmond County Board of Health. The house was torn down in 1956.

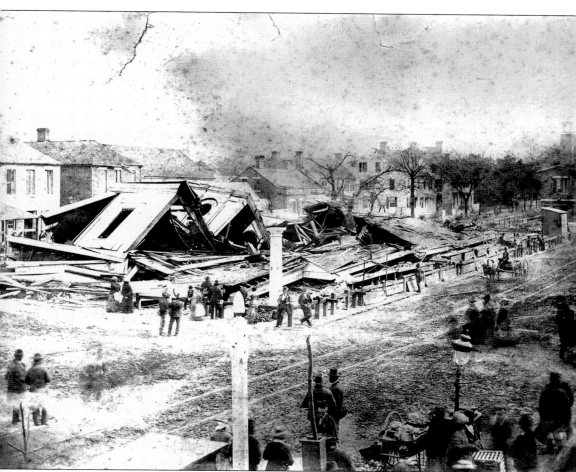

The Lower Market lies broken after the tornado hit. The Haunted Pillar and the small wooden structure to the left appear in both images. These two items were all that was left standing. The Lower Market was rebuilt in late 1878.

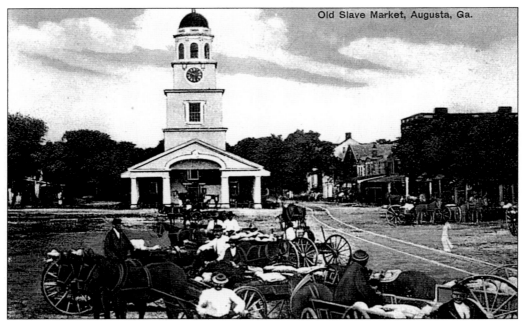

The Lower Market was originally built in 1830, after the previous structure burned. The building contained butcher stalls, meat shops, poultry coops, and stands for vegetables, fruits, and dairy products. Market goers could purchase farm animals and pets behind the building. The Lower Market also acted as a news center. This postcard provides an illustration of what the Lower Market looked like before the 1878 tornado. (Courtesy of Joseph M. Lee III.)

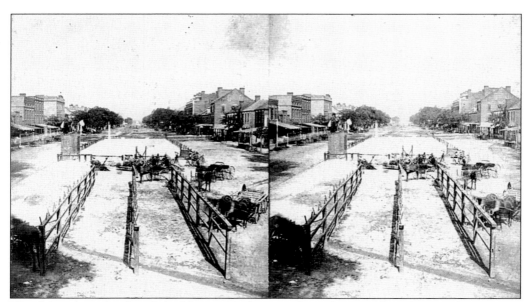

The debris from the demolished Lower Market was cleaned up swiftly and a corral was put up in its place. The remaining pillar and outhouse can still be seen in this image. Taken from the Gazelle Engine House, the image provides a view after the debris was removed. (Courtesy of Joseph M. Lee III.)

Two

FLOOD OF 1888

On Sunday, September 9, 1888, the Savannah River began to rise due to incessant heavy rainfall. Water inundated the city and even the banks of the Augusta Canal gave way. The water finally came to a standstill on September 11 and began to fall. The destruction was estimated at $1,000,000. Unfortunately, property damage was not the only loss the city suffered. Ten people drowned during the flood. Citizens rallied together, donating both food and money to relieve the flood victims.

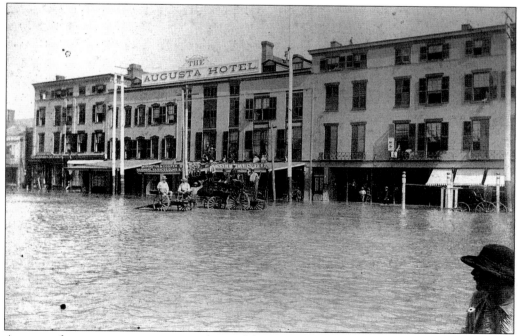

A group of men poses on a wagon in front of the Augusta Hotel. At the time of the flood, L.E. Doolittle ran the hotel, located at 607 Broad Street. The hotel rooms were on the second and third floors while businesses, such as Harrington and Cooper, occupied the ground level.

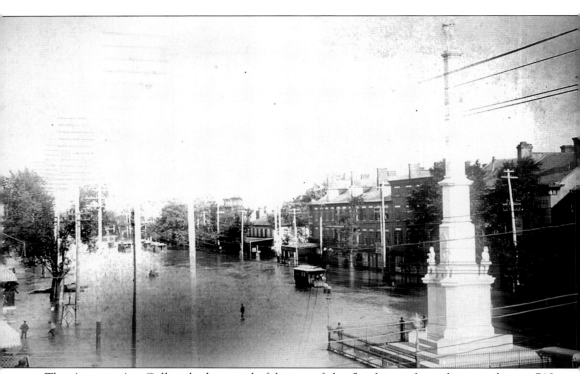

The Augusta Art Gallery had a wonderful view of the floodwater from their window at 712 Broad Street. This view is looking west. The trolley car was stranded in the middle of the street. In Augusta, trolley cars were not electric until 1890. The Augusta Art Gallery sold photographs of Augusta's Great Flood for 25¢. (Courtesy of Joseph M. Lee III.)

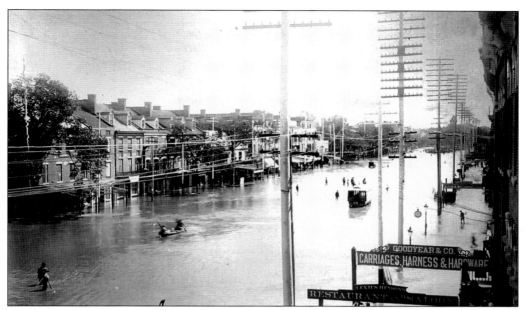

An opposite view from the one below, this image looks east down Broad Street. Lexus Henson's Restaurant and Saloon, in the foreground, was a very popular eating establishment. Henson, an African American, served whites only. (Courtesy of Joseph M. Lee III.)

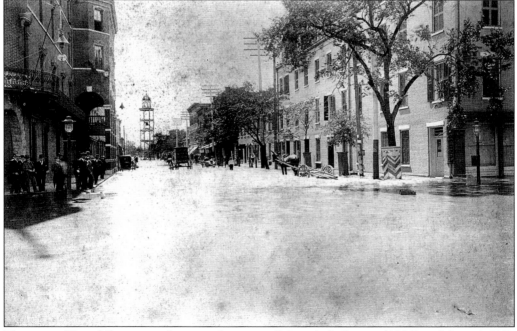

The area of Broad Street seen here was known as Schneider's Corner (802 Broad Street). E.R. Schneider was a wholesale and retail dealer in fine wines, cigars, brandies, and tobacco. Across Jackson Street (Eighth) was the Arlington Hotel, built in 1887. The fire alarm bell tower, Big Steve, stands in the background.

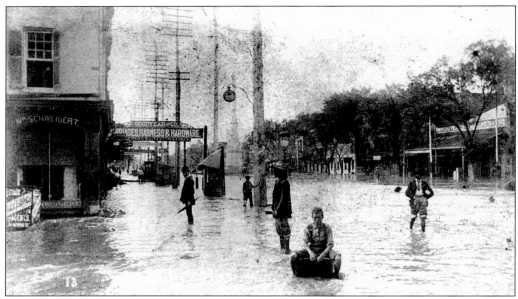

The floodwaters did not seem to bother some people. A few gentlemen simply rolled their pants above their knees and continued on their way. The corner of Seventh and Broad, seen here, was known as Schweigert's Corner. William Schweigert owned the jewelry store at 702 Broad Street. Schweigert later sold his business to his son-in-law when he became president of the Union Savings Bank. The Augusta Photo Co., which took this photograph, was located upstairs from the jewelry store.

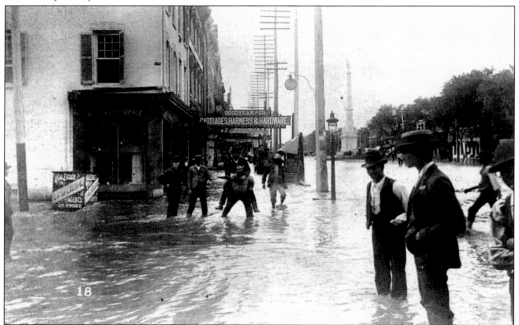

Many people made extra money by providing transportation across the flooded streets. This photograph was taken at Schweigert's Corner (Broad and Seventh) and was produced by the Augusta Photograph Co.

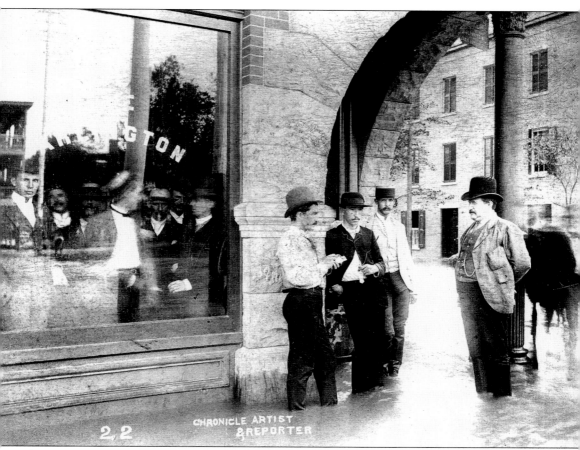

A reporter interviews one man outside of the Arlington Hotel, which burned in the December 1899 fire. The Augusta Photograph Co., which operated from 1886 to 1895, took this photograph. During the 1888 flood, Hamilton Bigelow was the manager of the company.

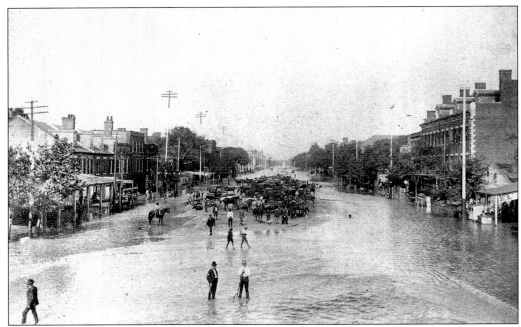

Livestock are herded to high ground during the 1888 flood. This area was near a fountain in the middle of Broad Street in the 500 Block and was one of the last areas flooded.

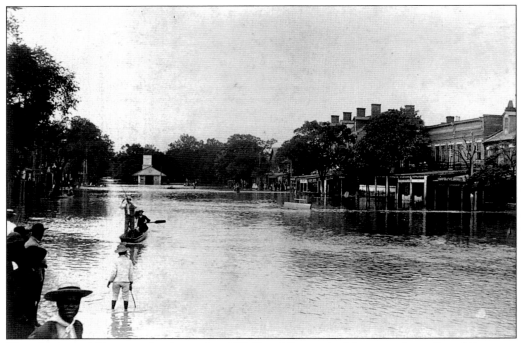

Platt Artist and Photography, located at 712 Broad Street, looking west down Broad Street to the Upper Market House, took this photograph. The Upper Market House was located at the intersection of Twelfth and Broad Streets. It was identical to the Lower Market building, which was destroyed by the 1878 tornado.

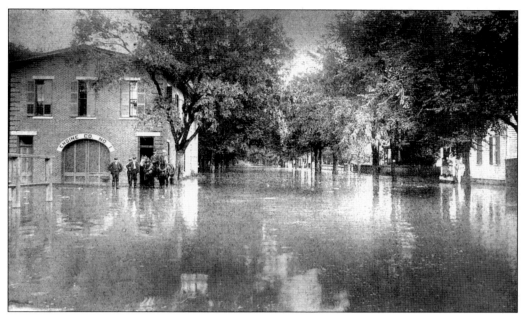

Engine Co. No. 1 stood in the middle of the 400 block of Broad Street. The Augusta Fire Department had four steamers with hoses and one hook and ladder truck. At the time of this flood, the city appropriated $40,000 annually to the department.

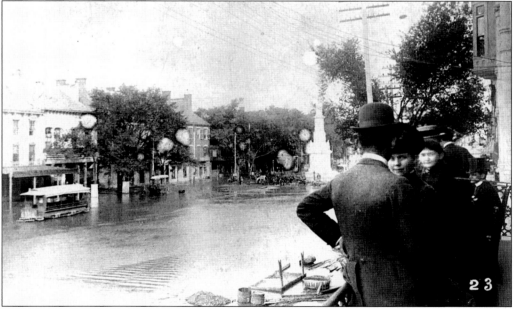

The 700 Block of Broad Street was frequently photographed during the 1888 flood, simply because that is where the studio of the Augusta Photograph Co. was located (702 Broad). Most of the photographs seen here of the 1888 flood were produced by that company. This photograph provides a view looking north. With nowhere to go, citizens and visitors alike gathered in dry spots to chat. This group is gathered on the balcony of the Arlington Hotel. The Confederate Monument can be seen in the background.

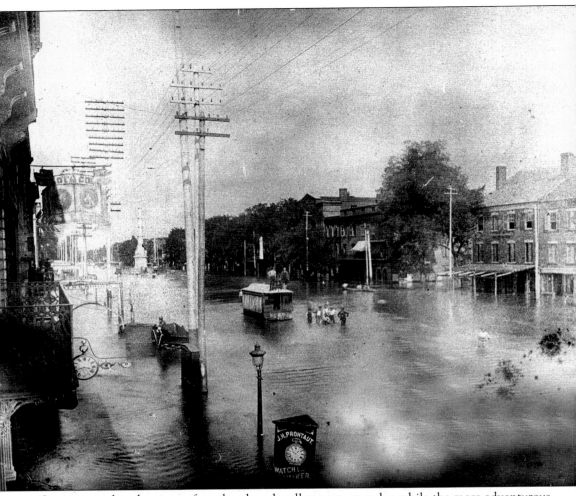

Some men take advantage of an abandoned trolley car to stay dry, while the more adventurous took their chances in the water. The trolley car service was suspended as the water got deeper. Pelot and Cole, located at 628 Broad Street (whose sign can be seen at the left of this image), took this photograph.

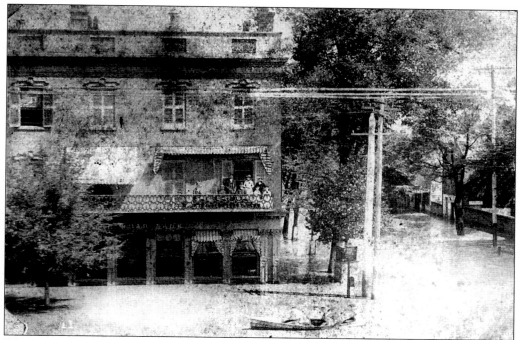

Water inundated the Georgia Railroad Bank, built in 1836. At the time of the 1888 flood, Charles H. Phinizy was president of the bank. This building, located at 701 Broad Street, was replaced with a more modern structure in 1902. (Courtesy of Joseph M. Lee III.)

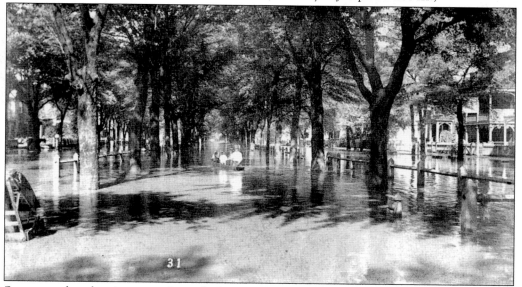

Some people take time to enjoy a little recreation in a time of crisis. This group enjoys a boat trip down Greene Street near Ninth (Campbell) Street. Boat trips were not always fun and games. It was reported in the September 11 *Augusta Chronicle* that Dr. W.H. Doughty Jr. was capsized from his boat and lodged against a tree. This accident happened near this same corner of Greene Street and Campbell Street. Chief Roulette of the fire department rescued Dr. Doughty.

Capt. Jiles M. Berry's home also suffered damage during the flood. The house stood at the corner of Fifth (Centre) Street and Greene Street. This view shows the muddy streets left after the floodwaters receded. Captain Berry was the proprietor of Excelsior Roller Mills, which produced meal and flour. The mill produced such brand names of flour as Grand Duke, Bob White, Our Drummer, and Sun Beam.

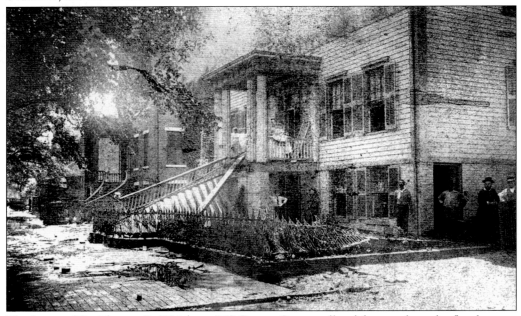

The home of Dr. Thomas R. Wright at 848 Greene Street suffered damage from the floodwaters. The front steps and iron fence nearly washed away in the rapid current. Dr. Wright founded the Margaret Wright Hospital, Augusta's second hospital. He named the institution for his mother, Margaret Bones Wright, a nurse. The Margaret Wright Hospital opened a school of nursing, the city's third, in 1909.

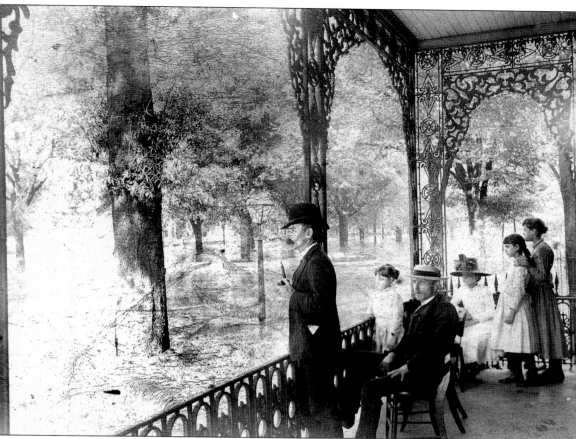

George S. Hookey and his family sit on the veranda of their home, at 465 Greene Street, and survey the floodwater. Hookey was a coal dealer and the superintendent of the Gas Light Co. of Augusta. Many of the exotic plants and flowers landscaped along Greene Street were washed away.

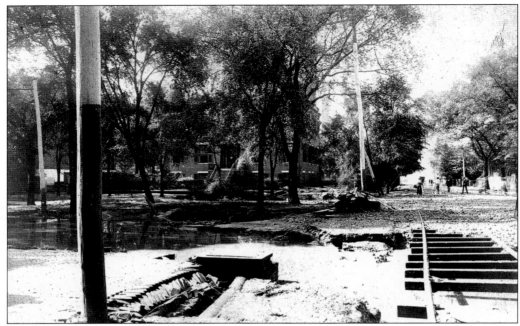

The following two images show severe damage caused by raging floodwaters. This is a view down Seventh (McIntosh) Street from the northeast of Greene. The railroad track was laid in the street for the trolley. The *Augusta Chronicle* printed repeated warnings for people to travel in the middle of the street due to washouts of the sidewalks.

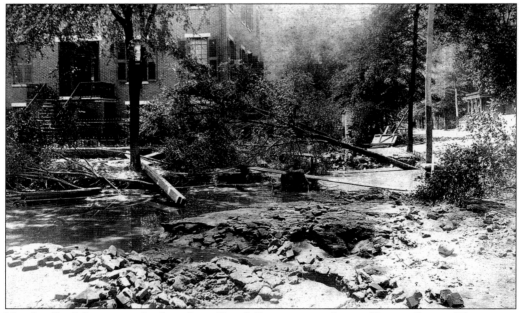

Nearly all of the streets leading from Broad Street emptied into Greene Street. This image provides a closer view of the home of Edward P. Clayton on the southeast corner of Greene and Seventh (McIntosh). E.P. Clayton was a cotton factor and commercial merchant. Augusta Photograph Co. issued both of these photographs.

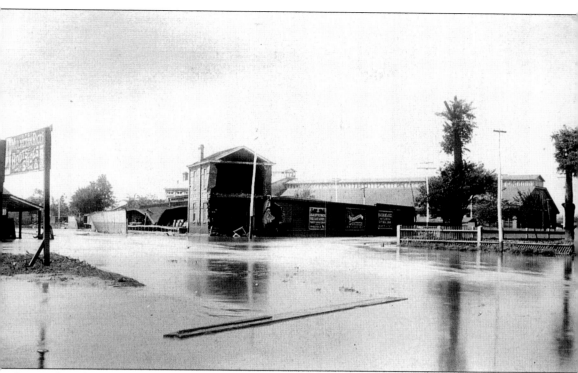

Lee and Bothwell's Warehouse did not fair much better in the 1888 flood. Five feet of water covered the street in front of the warehouse, floating beer kegs, barrels, and other debris. John C. Lee and James T. Bothwell were wholesale grocers. This warehouse was located at the corner of Walker and Twiggs Streets, known at the triangular block. A few days following the beginning of the flood, the wall of the warehouse fell down. (Courtesy of Joseph M. Lee III.)

The children provide a good measure of how severe washouts were in some neighborhoods. This photograph, taken by the Augusta Photograph Co., shows an area of Second (Houston) Street near Broad Street.

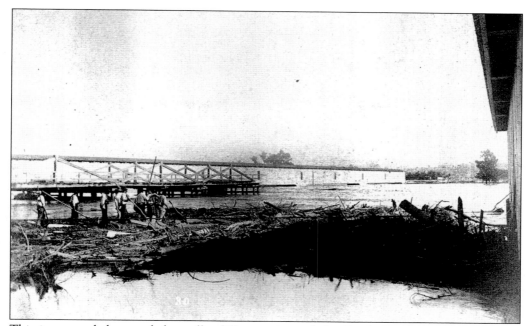

This image and the one below offer different views of the South Carolina Railroad Bridge over the Savannah River during the 1888 flood. The covered bridge is for the South Carolina Railroad. The Fifth Street Bridge next to it was partially washed out. At the time, the bridge was made entirely of timber. The Augusta Photograph Co. issued this photograph.

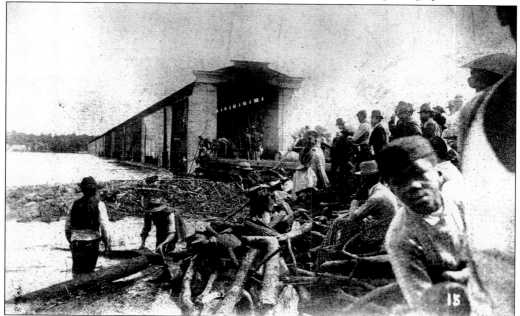

Many people survey the damage and work to clear debris at the South Carolina Railroad Bridge. A small part of the trestle gave way and all of the weatherboarding was pulled off. This photograph captures how high the Savannah River rose. This image was taken from the Augusta side of the river.

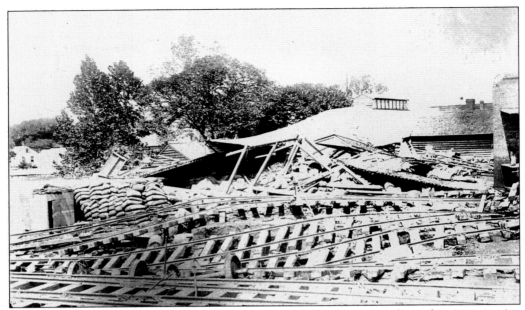

The 1888 flood caused severe damage, as illustrated by this image from the Augusta Art Gallery. This is a rear view of J.M. Berry's warehouse along with Georgia Railroad tracks. Berry's warehouse was located in the 900 block of Walker Street. The warehouse stored meal and flour. (Courtesy of Joseph M. Lee III.)

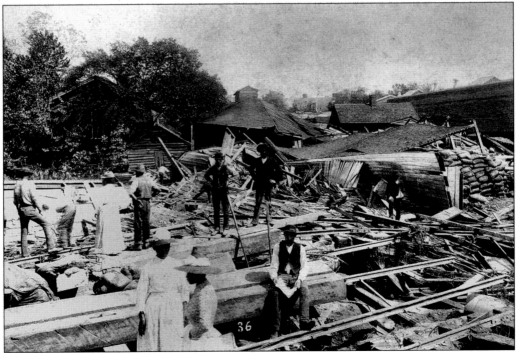

A group of people survey the severe damage caused by the rapid current of the floodwaters. This image provides yet another view of Captain Berry's warehouse.

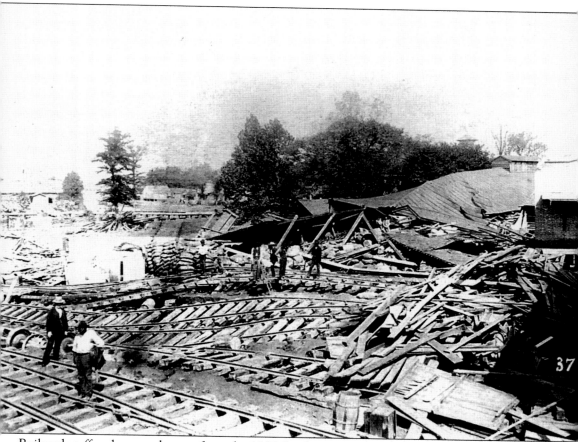

Railroads suffered severe damage from the 1888 floodwater. Once the water was gone, twisted steel and broken wood could be seen. The remains of Captain Berry's warehouse are visible to the side. Davidson Grammar School, also in this area, crumbled on its foundations. The railroad tracks crossed the third level of the Augusta Canal. The tracks crossed Ninth (Campbell) Street and led to the Georgia Railroad yards. The Augusta Photograph Co. took this photograph.

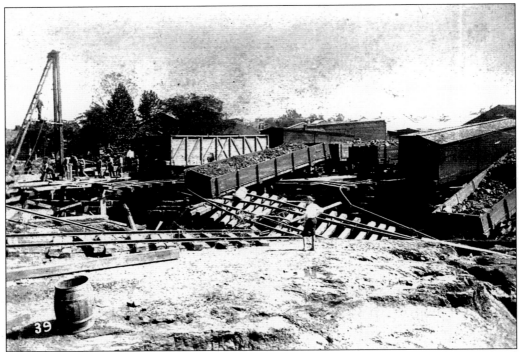

Boxcars washed off the tracks and even off their own axles. Workers from the Georgia Railroad are pictured standing in the background. The Georgia Railroad yards were located at the third level of the Augusta Canal. The canal appears in the center of the photograph where the tracks have fallen in. The Augusta Photograph Co. took this photograph.

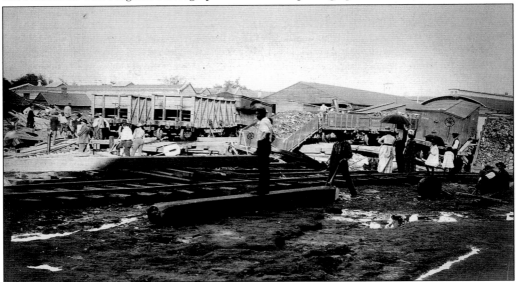

This view of the flood damage shows the tracks of the Georgia Railroad. The A-frame roof of the Georgia Railroad car shed appears in the back. The floodwaters tore the main line to pieces on the third level of the Augusta Canal, within 400 yards of the depot. (Courtesy of Joseph M. Lee III.)

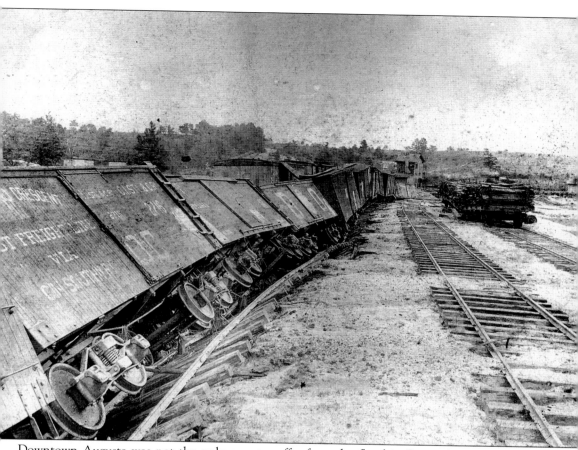

Downtown Augusta was not the only area to suffer from the flood in September 1888. This image shows the demolished tracks of a derailed train on the South Carolina Railroad in Hamburg, South Carolina. The Augusta Photograph Co. issued this photograph as well as the one on the following page.

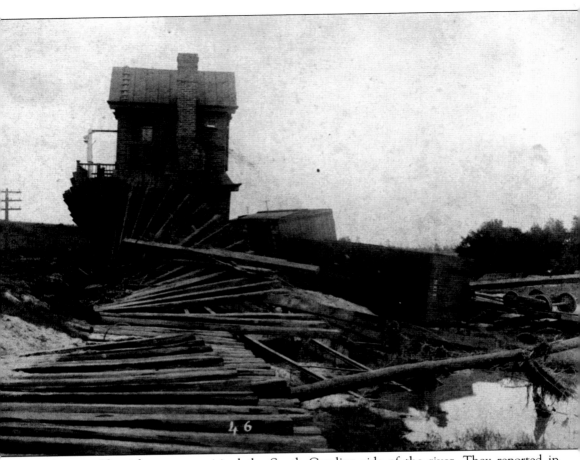

Augusta Chronicle reporters visited the South Carolina side of the river. They reported in the September 13 issue that, "The wreck in Hamburg was even worse than in Augusta, and many of the houses were still submerged and surrounded by water. The trestle from the Charlotte, Columbia, and Augusta railroad bridge was washed away for several hundred yards and the tracks of the South Carolina railroad were all away and warped about in all directions." This image offers another view of that destruction to the tracks of the South Carolina Railroad in Hamburg.

Three

FLOOD OF 1908

In August of 1908, Augusta suffered one of the worst floods in terms of volume that the city had ever seen. The hotels, department stores, newspapers, telegraph offices, banking institutions concentrated on Broad Street, and principle business area between Sixth and Tenth Streets were all flooded. Six thousand people were left essentially homeless, without clothing or food. Floodwater covered 25 square miles. Of the five bridges that cross the river, a railroad and a footbridge were destroyed. The others were so damaged that they were unfit for travel for several days. In addition to a substantial sum set up by citizens and the Augusta Chamber of Commerce, neighboring towns sent in relief funds to help provide for those suffering loss.

1908 **Flood Scenes** **1908**

AUGUSTA, GEORGIA

Where twenty-five lives and $1,500,000 were lost.

Showing the remarkable overflow of water from the Savannah river and the destruction left in its wake.

Houses, bridges, boats and pavements were torn to shatters and thousands of people were homeless, hungry and cold for days.

COPYRIGHT 1908—MURPHY & FARRAR)

Murphy and Farrar, Inc. produced a booklet to commemorate the 1908 flood; the cover of the booklet is seen here. This postcard book could be sent to family and friends. The booklet folded out and contained 12 flood photographs of trains, scenes on Broad Street, the wreck of the *Two States*, and many others.

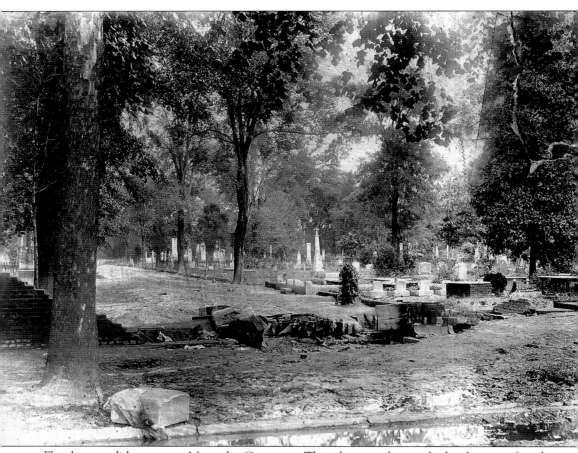

Floodwaters did not spare Magnolia Cemetery. This photograph reveals the damage after the water receded. The swiftness of the water caused damage to the wall. This portion is at the dead end of First Street (Cemetery Street) at the west wall along Third Street (Augusta Street). The repair work is visible in the wall today. Magnolia Cemetery was previously known as City Cemetery and became city-operated in 1817.

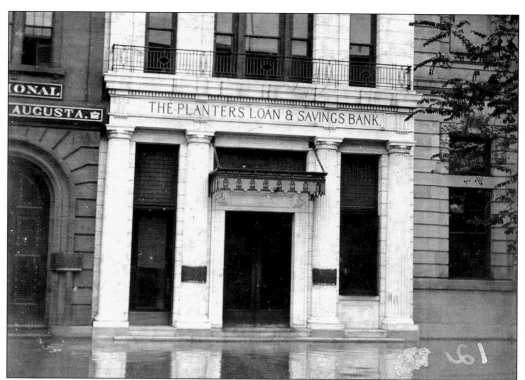

The Planters Loan and Savings Bank, located at 705 Broad Street, was new at the time of the 1908 flood. Linwood C. Hayne was president of the bank. Hayne would later become mayor of Augusta. The Planters merged with the Citizens and Southern Bank in 1921. (Courtesy of Joseph M. Lee III.)

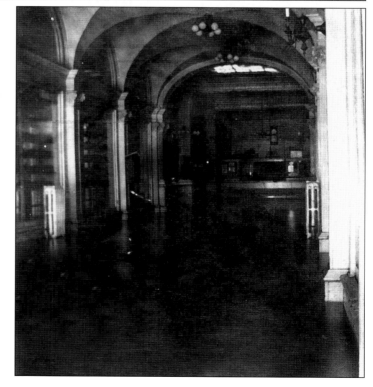

One of the only interior photographs taken during the flood, this postcard shows water standing in the lobby of the Albion Hotel, located at 738 Broad Street. (Courtesy of Joseph M. Lee III.)

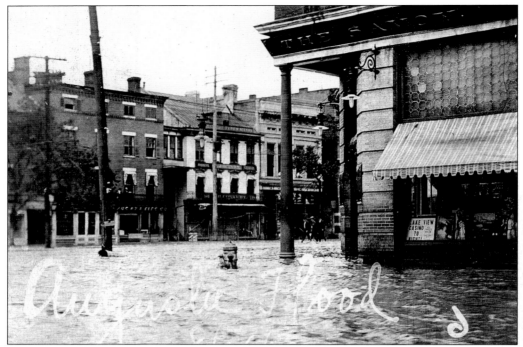

Floodwater filled the southeast corner of Eighth and Broad Streets. The Savoy, located at 760 Broad Street, was a specialty store and restaurant. It was known for its "fine service and Fine Syrup with the prettiest parlors in the South." (Courtesy *Walker's Magazine*, October 1905.)

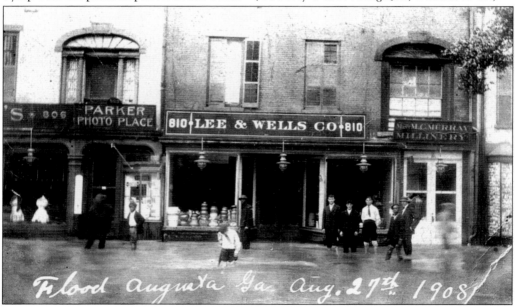

Several gentlemen decide to enjoy the day, regardless of the weather. This image was taken in front of Lee and Wells Co., also known as the China Palace, located at 810 Broad Street. Owen C. Lee and George H. Wells operated the store, which specialized in china, glassware, and house furnishings.

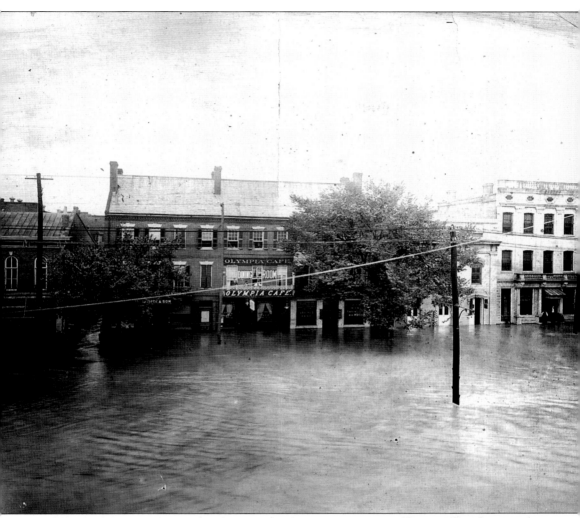

The entire downtown area filled with rising floodwater in a matter of hours. This photograph provides an image of the 800 block of Broad Street. James and Charles Malevis and C.H. Kempures operated the Olympia Café, located at 835–837 Broad Street. The café offered a "Private Dining Room for Ladies."

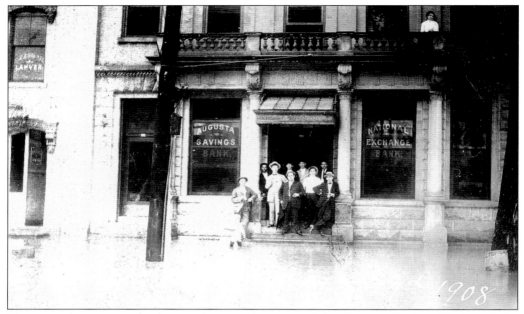

These gentlemen stay dry by standing on the steps of the Augusta Savings Bank and the National Exchange Bank. These two banks shared the space at 823 Broad Street. (Courtesy of Joseph M. Lee III.)

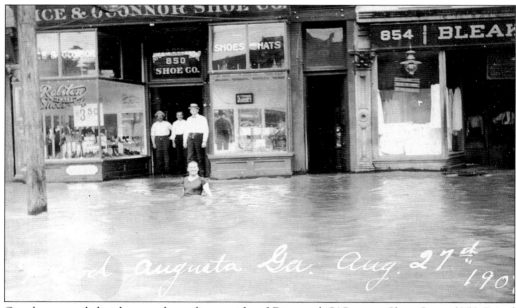

One brave soul decides to take a dip outside of Rice and O'Connor Shoe Store (850 Broad Street) and Arthur Bleakley's Dry Goods and Notions (854 Broad). In the August 29, 1908 edition of the *Augusta Chronicle*, Rice and O'Connor placed an ad stating, "We are pleased to state that we are uninjured by the disastrous flood, and that we are ready and open for business at our two stores. 20 Cases Rubber Boots will be on sale Saturday morning." (Courtesy of Joseph M. Lee III.)

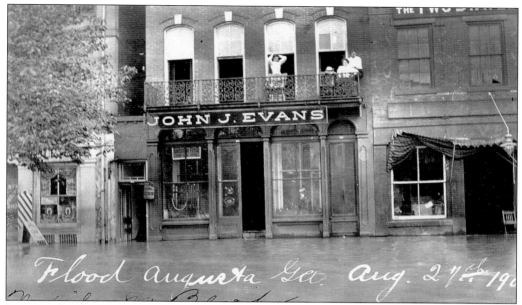

In 1908, floodwaters inundated downtown businesses. This postcard shows the shop front of John J. Evans, president and treasurer of Hogrefe Hardware Co., at 869 Broad Street. Upstairs from the store was Kate V. Mustin, a dressmaker. The people on the balcony are probably Kate Mustin and her family. (Courtesy of Joseph M. Lee III.)

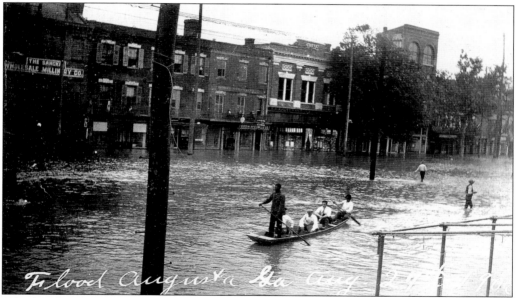

Whether for pleasure or simply for practical transportation, a group of gentlemen takes a boat ride down the 900 block of Broad Street during the 1908 flood. Water began to pour into the streets early Wednesday morning and rose rapidly. The city remained underwater from 9 a.m. Wednesday until 11 p.m. Thursday. Several people were stranded wherever they happened to be when the floodwaters began to rise. (Courtesy of Joseph M. Lee III.)

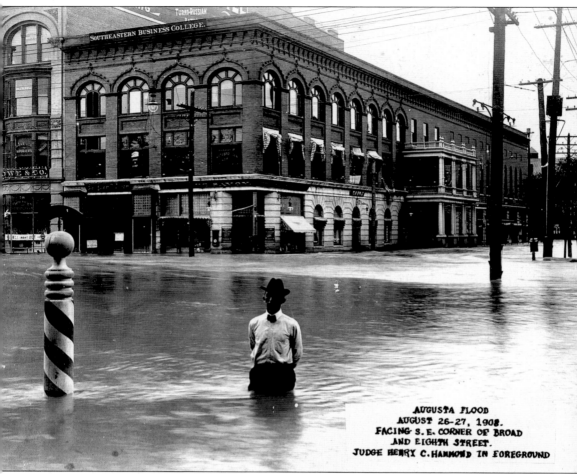

This is one of the best-known photographs taken during the 1908 flood. The image has been published numerous times. The gentleman braving the rising floodwaters is the Honorable Henry C. Hammond, a judge in Superior Court Augusta Circuit. His office was located in the Dyer Building. The photograph was taken at the intersection of Eighth and Broad Streets. The Southeastern Business College is in the background.

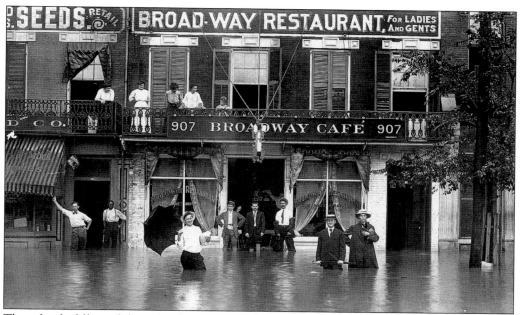

These lively fellows did not let the water get them down. They bravely wade out to pose for a photograph. They gather in front of the Broadway Restaurant, "for Ladies and Gents," located at 907 Broad Street and operated by Peter Thevous.

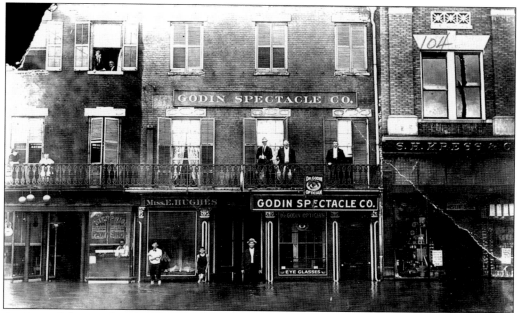

A view of the south side of the 900 Block of Broad Street provides a glimpse of a variety of Augustans. The people on the upper piazza are identified from left to right as R.W. Roper, Jules Godin (owned and operated Godin Spectacle Co.), and his son, Dr. Henry J. Godin. The building to the left housed Miss Ellie Hughes's millinery store. On the right was the S.H. Kress Building.

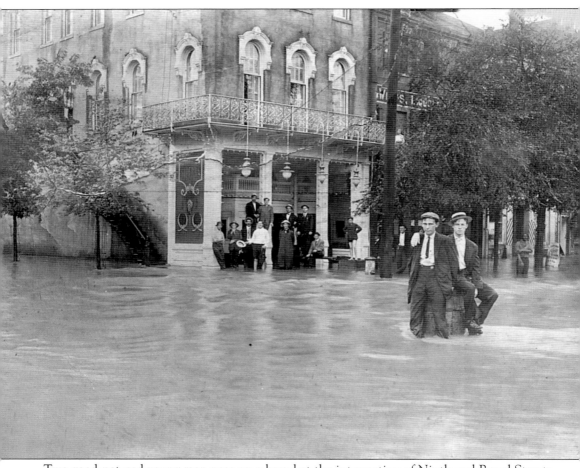

Two good-natured young men pose on a barrel at the intersection of Ninth and Broad Streets. Behind them, another group gathered in front of the Superba Theatre. The Superba became the Dreamland Theatre around 1911.

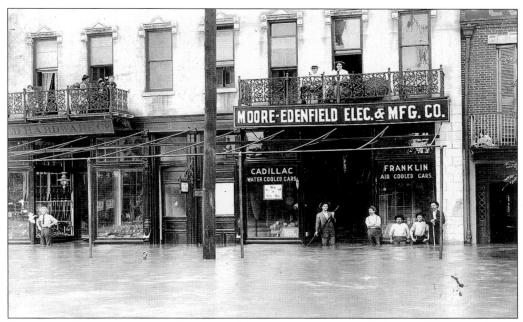

Deep water does not seem to bother some, while others remain dry on balconies. These gentlemen relax outside of Moore-Edenfield Electric and Manufacturing Co. Located at 1033 Broad Street, Moore-Edenfield was operated by Richard J. Edenfield. Next door was the Wingfield Hardware Co. Merchants moved their goods, hastily putting them above the probable damage line. However, they were forced by rising floodwaters to abandon their tasks.

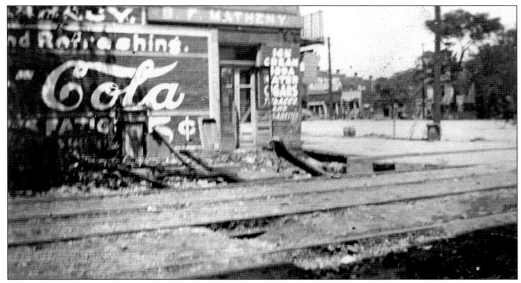

As the water recedes, deep washouts caused by the current materialize in the sidewalks. This image was taken outside of Model Pharmacy at 1102 Broad Street, operated by Benjamin F. Matheny. (Courtesy of Joseph M. Lee III.)

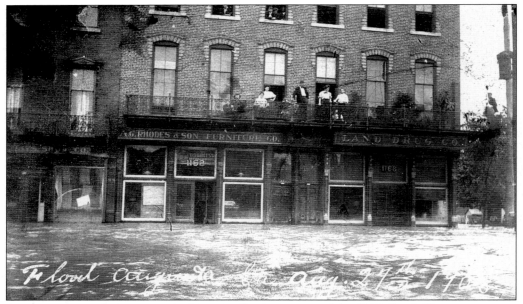

A group sits on a balcony overlooking the flowing waters of the 1908 flood. Their apartments are upstairs from A.G. Rhodes and Son Furniture Co. and the Land Drug Co. at the corner of Twelfth and Broad Streets. (Courtesy of Joseph M. Lee III.)

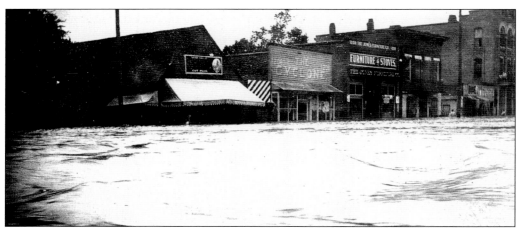

Many of the businesses along Broad Street filled entirely with floodwater. This postcard shows the businesses along the 1200 block of Broad. These included Hambal Evans (clothes cleaner), Annie Wolfe (dry goods), Jones Furniture Co., Mr. Steinberge (dry goods), and Frank L. Thomas (news dealer).

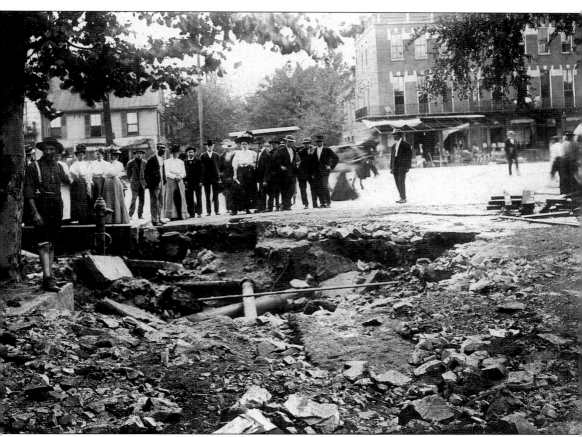

The swift current caused havoc outside of Claussen's Corner Bakery. The water demolished roadways and sidewalks to reveal the pipes below. Earlier, Mayor William M. Dunbar had warned against vehicle traffic while water still covered the streets for fear of cave-ins, such as this one. Claussen's Bakery, located at 1002 Broad Street, is at the far left of the image.

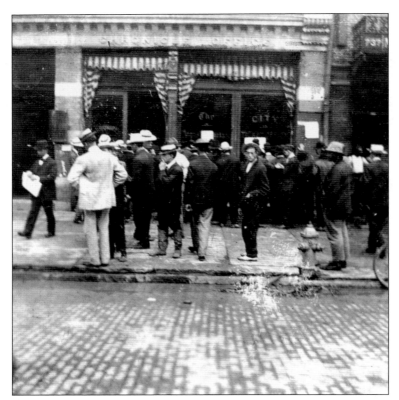

Many people rush to the Chronicle Building at 739 Broad to find out the latest news once the floodwater recedes. The *Chronicle* had a bulletin board out front, on which they posted the latest updates. (Courtesy of Joseph M. Lee III.)

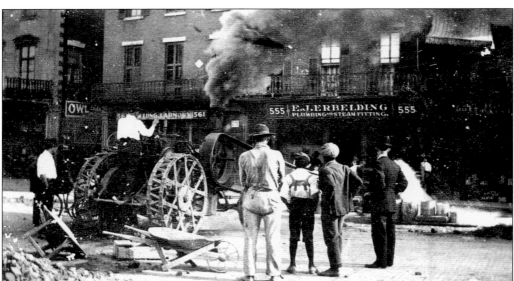

As the water begins to recede, many people begin the enormous task of cleaning up downtown. Here, a work crew pumps water out of the cellar of E.J. Erbelding. Erbelding was a plumbing, steam and gas fitting, heating, sewer, and waterworks contractor. In some instances, prisoners assisted in cleaning the streets. This shop was located at 555 Broad Street. (Courtesy of Joseph M. Lee III.)

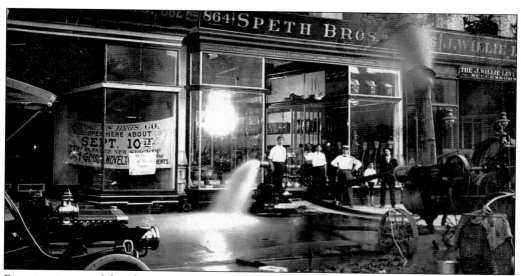

Pumping is part of the clean-up effort to remove water from all the downtown businesses. This image captures the pumping that took place at Speth Bros. Stove and Hardware Store, 864 Broad Street. The Board of Health recommended the use of lime, kerosene, and disinfectants to clean the streets. (Courtesy of Joseph M. Lee III.)

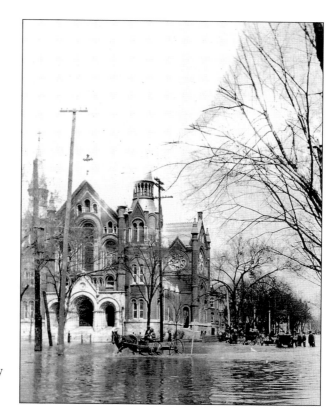

Sacred Heart Catholic Church was dedicated December 2, 1900. The church, shown here during the 1908 flood, is located on the northwest corner of Greene Street and Thirteenth (McKinne) Street. The church held its last service July 4, 1971. The building now houses the Sacred Heart Cultural Center.

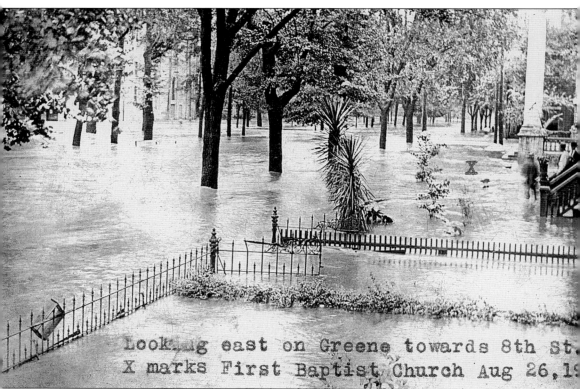

Looking east on Greene towards 8th St.
X marks First Baptist Church Aug 26, 19

The business district was not the only area to suffer. This postcard shows how the residential areas were inundated with floodwater. These houses were located along the 800 block of Greene Street. The yard in front is at 822 Greene, the residence and office of Dr. William H. Doughty. The message on the reverse is dated September 28, 1908. A portion of the message reads, "Augusta is slowly getting right. No water yet, and the streets are still dark." Recovery from this flood obviously took some time.

Mrs. Markwalter mailed this postcard to Grace Arnold of Frewsburg, New York. On the back she writes, "Hello Grace, I am still in the land of the living after a terrible experience during the flood. We lost nothing but Augusta was surely in a terrible way. Hoping to see you this winter. Mrs. Markwalter." The postcard shows the 600 Block of Greene Street. The house in the middle belonged to J. Frank Carswell of Burssey and Carswell Wholesale Grocers. (Courtesy of Joseph M. Lee III.)

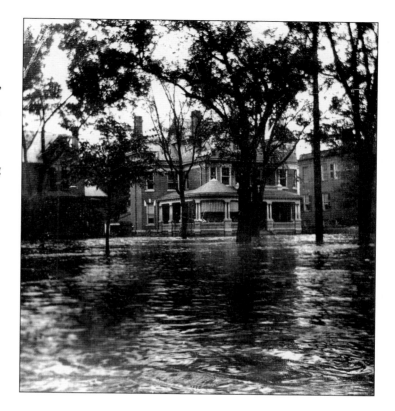

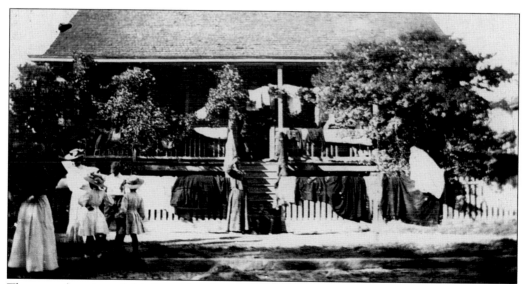

The exact location of this home is unknown. However, the photograph provides an excellent example of how the citizens of Augusta begin to dry out their belongings after the 1908 flood. (Courtesy of Joseph M. Lee III.)

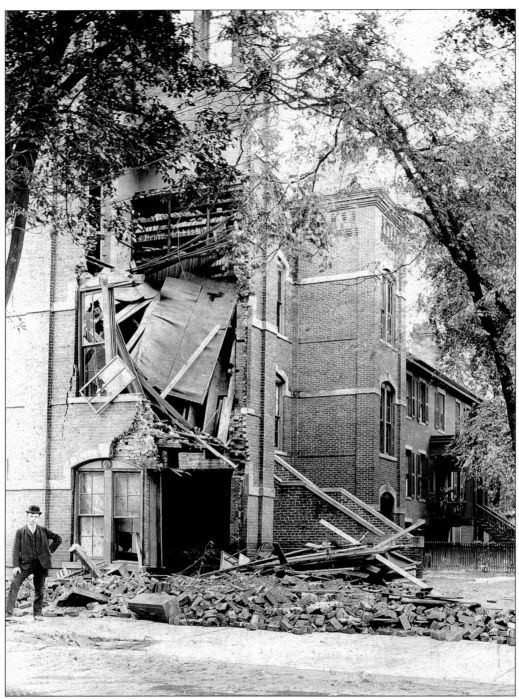

The August 28, 1908 *Chronicle* reported that of all the public schools in Augusta, the Central Grammar School at the northeast corner of Telfair and Seventh Streets suffered the most damage. This photograph provides one view of the damage to the school's tower. The tower stored the school's stock of books.

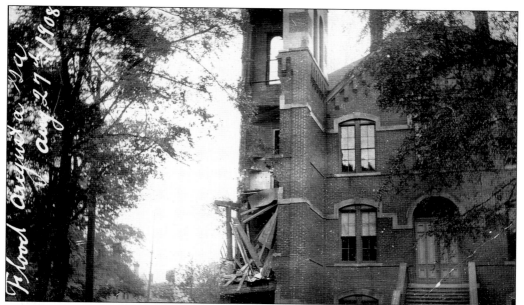

The Central Grammar School tower had to be torn down after it was discovered that it would be necessary to rebuild the tower entirely from the foundation up. The basement of this school was also flooded. The *Chronicle* reported that this basement housed the superintendent's office and that papers and archives in the office were waterlogged but salvageable. (Courtesy of Joseph M. Lee III.)

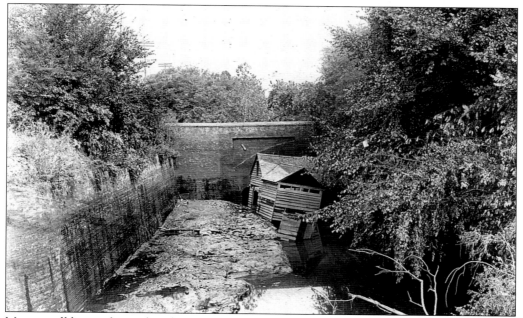

Many small houses located in the narrow alleys by the canal banks were overturned and carried away from their foundations. This house was swept away by the current. It lodged against the Fifth Street Bridge over the third level of the Augusta Canal, just east of Hawks Gully. Broad Street is on top of the embankment to the left.

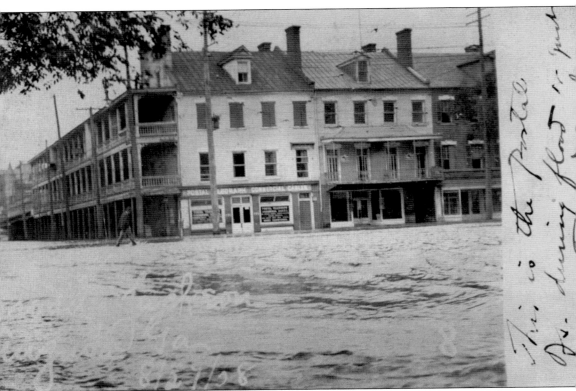

The intersection of Broad and Eighth Streets was an active business area. This postcard provides an intermediate view in 1908, after the floodwater had gone down. The building on the corner was the library building (769 Broad). At the time of the flood, Henry W. Carr was the librarian. As the sign states, this building also housed the Postal-Telegraph Cable Co. (771 Broad). This corner building was later renovated and turned into Union Savings Bank. The building to the right, at 767 Broad Street, held the Irish-American Bank with Patrick Armstrong as president.

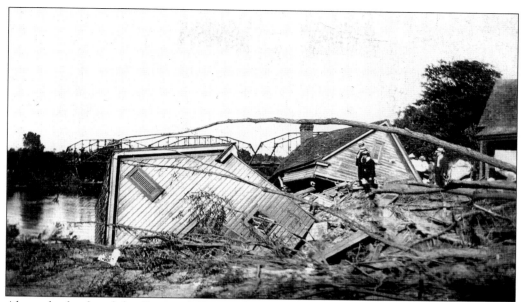

Along the banks of the Savannah River, the flood caused severe damage. These houses are located along Market Street, west of the Thirteenth Street Bridge, seen in the background. The northwestern section of the city was hardest hit. Reportedly, some people spent Wednesday night of the flood on the roofs of their homes. (Courtesy of Joseph M. Lee III.)

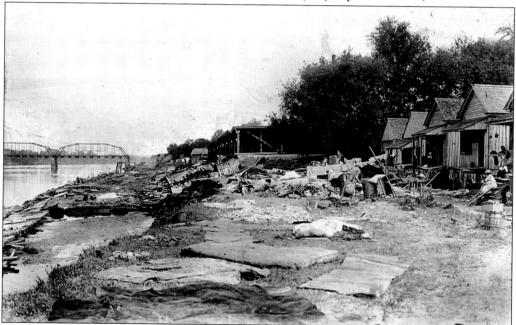

The inhabitants of this area of the east end of Market Street, looking west along the Savannah River, were among the hardest hit. Many of these people were stranded and went without food for several days. Whether these items were intentionally placed outside to dry, or if they were washed out there by floodwaters, is unclear. The remains of the Augusta Terminal Railway tracks are at the left of the photograph.

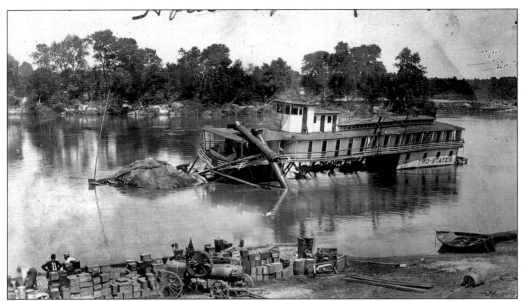

The *Two States* was a steamboat that belonged to the Planters line. This postcard was sent to C.S. Thompson at Camp Columbia, Cuba. The message written on the back says, "Two States sunk with 75 people on it and they had a hard time saving them all. You can see how high it came on the boat." The boat hit a hidden obstruction in the river, thought to be a pier of the Centre Street Bridge.

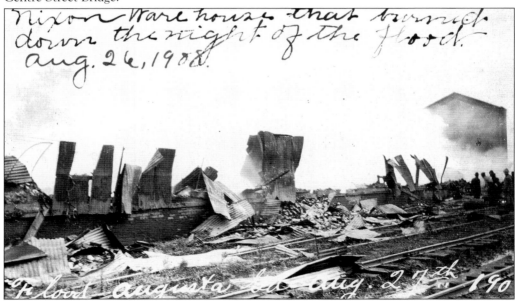

The Nixon warehouse suffered more than just water damage. The Nixon Grocery Co. was located at McIntosh Street and Fenwick Street. One of five fires broke out at the warehouse on the night of August 26, 1908. The warehouse reportedly caught fire due to lime. This postcard shows all that remained. Five people were in the warehouse when the fire started and they were forced to jump into the water to escape. All five died, including Harry Carr, the bookkeeper. (Courtesy Joseph M. Lee III.)

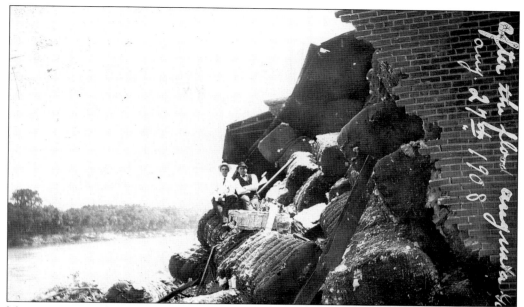

Many cotton warehouses were built along the river to allow for easy shipping. During the 1908 flood, many of these brick buildings suffered major damage. This image and the one below show the Augusta Warehouse and Banking Co. located on the corner of Market and Thirteenth Streets. In this photograph, two gentlemen sit on cotton bales that tumbled out when the corner of the building was washed away by floodwaters. (Courtesy Joseph M. Lee III.)

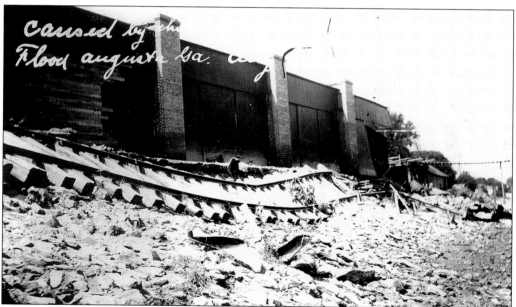

The back of the Augusta Warehouse and Banking Co., also known as the Reid Warehouse, ran parallel with the Savannah River. The damaged corner from the above image can be seen on the right. The damaged Thirteenth Street Bridge appears in the background. (Courtesy Joseph M. Lee III.)

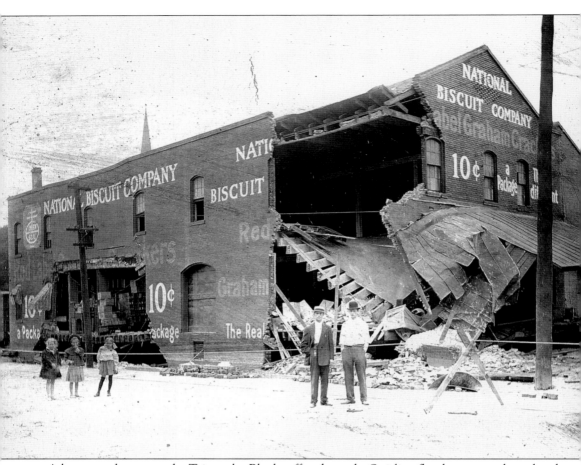

A large area known as the Triangular Block suffered greatly. Swirling floodwaters weakened and undermined the foundation of the National Biscuit Co., severely damaging the building. The foundation was so weakened on the south side that, on the following Friday, the walls collapsed exposing storerooms and offices. The National Biscuit Co., located at 640 Walker Street, was best known for the "Uneeda Biscuit."

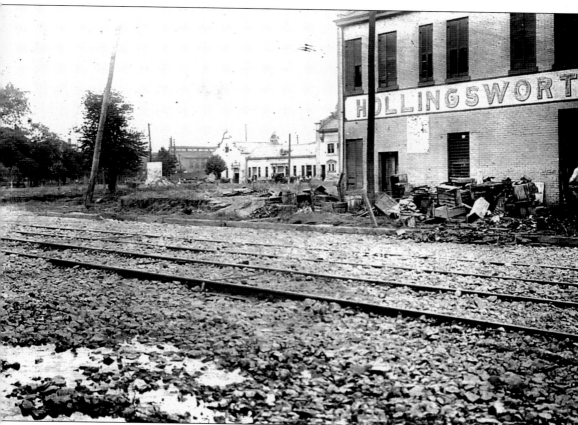

As the floodwater went down, items that had been caught in the current were haphazardly deposited. This photograph shows a pile of debris, consisting of furniture and barrels, which landed against the Hollingsworth and Co. building. This building was located at 502 Ninth Street at the corner of Telfair. Hollingsworth was operated by P. Virgil Hollingsworth. Union Depot can be seen in the background.

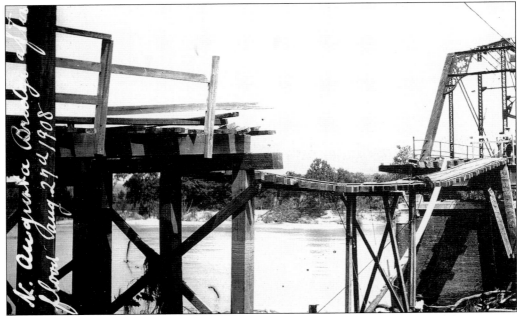

Part of the North Augusta Bridge (Thirteenth Street) washed away during the 1908 flood. This image provides a view of the southern approach with only the trolley tracks hanging. After several days without the ability to travel, some enterprising citizens began to use a ladder so pedestrians could reach the bridge and walk across. Complete repairs to the North Augusta Bridge cost $2,075. (Courtesy Joseph M. Lee III.)

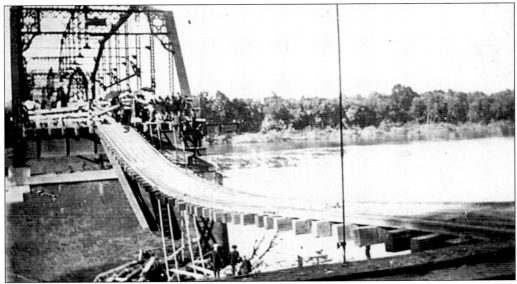

Portions of the North Augusta Bridge washed away with the swift current. The approaches were constructed out of wood. This postcard shows a level view of the portion of trolley track left behind. Pedestrians, frustrated with not being able to cross, climb a ladder in the background. (Courtesy of Joseph M. Lee III.)

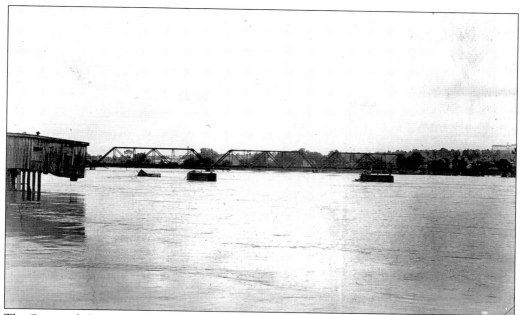

The Savannah River wreaked havoc on almost everything in its path. Both the Centre (Fifth) Street Bridge (in foreground) and the old South Carolina Bridge were completely wiped out, leaving only their piers standing in the river. The Southern Railroad steel bridge (Sixth Street) withstood the raging waters.

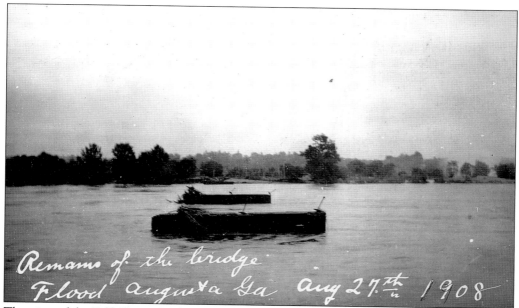

The piers of the Fifth Street Bridge were almost completely covered when the river levels were at their highest. The South Carolina and Georgia Railroad Bridge, at the foot of Sixth Street, gave way to the current at 3 p.m. on Wednesday. The Georgia side and middle span struck the city Fifth (Centre) Street Bridge, breaking it. The Centre Street Bridge gave way completely. (Courtesy Joseph M. Lee III.)

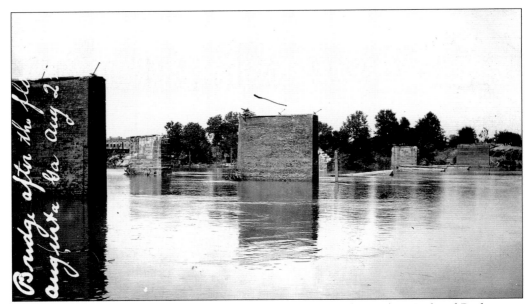

This close-up was taken after the floodwater receded. The South Carolina Railroad Bridge gave way at 3 p.m. on Wednesday August 26. The Georgia end collided with the City Bridge at Centre Street, taking the entire Centre Street Bridge with it. (Courtesy Joseph M. Lee III.)

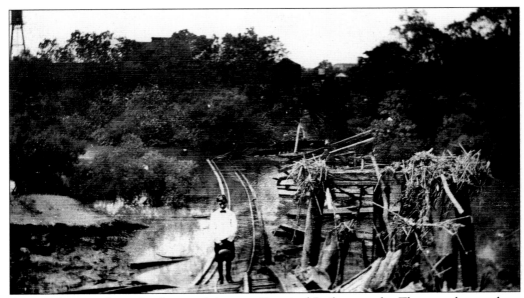

A young boy stands on the destroyed Augusta Terminal Railway tracks. These tracks ran along the banks of the Savannah River. (Courtesy Joseph M. Lee III.)

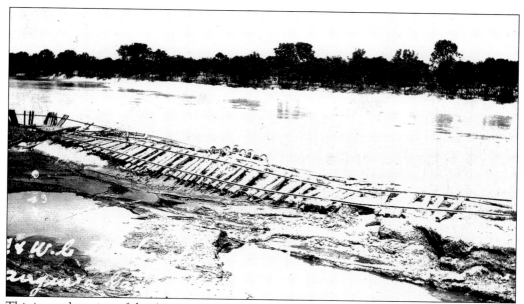

This is another view of the Augusta Terminal Railway tracks as they were washed out along the riverbank. Augusta Terminal Railroad was owned and operated by the Charleston and Western Carolina Railroad. (Courtesy Joseph M. Lee III.)

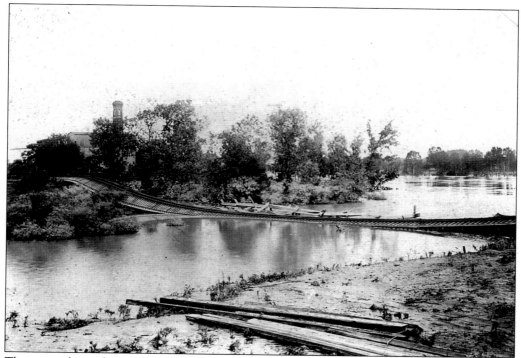

The image shows the remains of the Augusta Terminal Railway trestle. The view is along Hawks Gully looking west toward the Savannah River. The chimney in the background belonged to the Interstate Ice and Fuel Co.

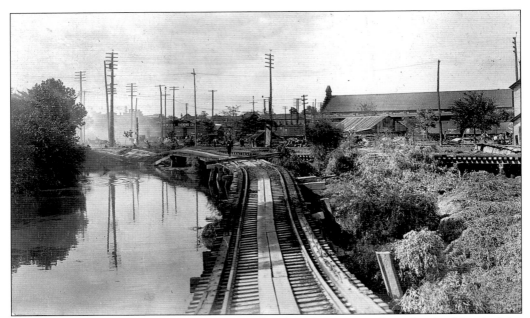

This postcard shows the destruction to the railroad tracks running along the third level of the Augusta Canal from Calhoun Street, looking north towards Fenwick and Ninth Streets. The long building in the background is Union Station. Union Station was located on Eighth Street on the site where the post office currently sits. (Courtesy of Joseph M. Lee III.)

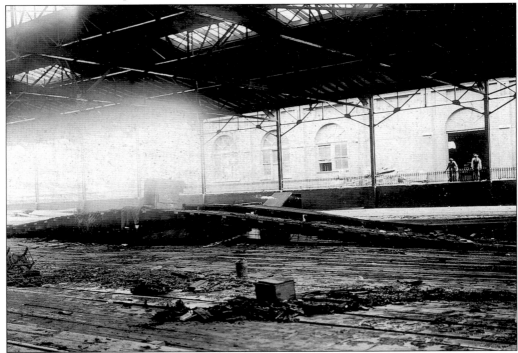

Once the floodwaters receded, extensive damage from the raging floodwater became apparent. The damage seen here took place at the Union Depot, beneath the train shed.

Four

FLOODS OF
1912 AND 1913

For two consecutive years, Augusta suffered from flood damage. In 1912, the Savannah River began to rise once again on March 16. In 1913, almost a year to the day, on March 15, Augustans were once again fighting water. The 1913 flood was not as severe as the one of 1912; however, the 1913 flood is better documented. The mayor wished to spare the public much of the expense that was incurred after the 1908 flood. In 1912, the city council made a large contribution for clean up. Old fire engines went to work pumping out cellars in the business section. The 1913 flood mainly affected the northeastern part of the city. Most of the businesses remained dry thanks to advance warning and preparation. High water temporarily stopped work on the levee, but work resumed once the water levels had dropped.

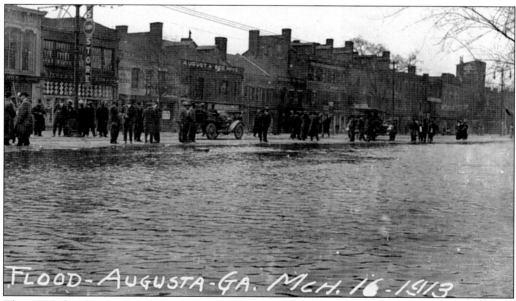

The 1913 flood caused the least amount of damage on the south end of Broad Street. Water only covered the lowest areas of the 900 block. People were forced to gather along the area that was uncovered.

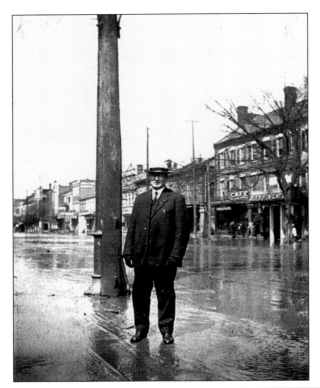

Dr. Orlin K. Fletcher, an Augusta dentist, stands at the edge of floodwaters during the 1912 flood. Behind him stretches the 800 block of Broad Street. The basement of the Dyer Building, located at the corner of Eighth and Broad Streets, was flooded at an early hour and the Rathskellar Club was full to the ceiling. (Courtesy of Joseph M. Lee III.)

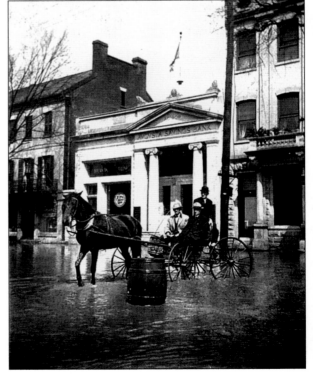

Gentlemen find a dry mode of transportation in this photograph. They are, from left to right, George J. Heckle, Dr. Orlin K. Fletcher, and Mr. Grealish. On March 16–17, 1912, downtown Augusta was once again inundated with water. (Courtesy of Joseph M. Lee III.

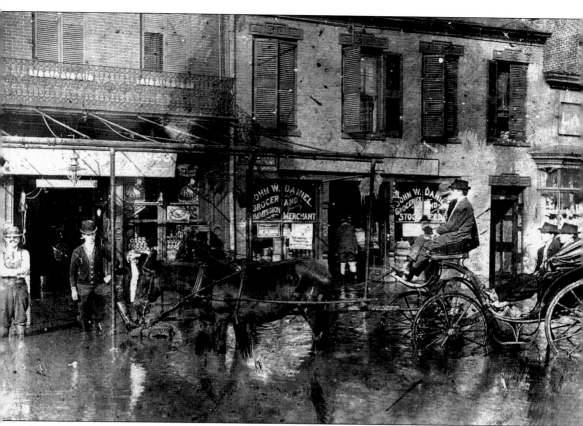

Broad Street was the center of the business district. Augusta photographer Waddell took this photograph along the 1000 block of Broad Street. Merchants in this photograph are Henry M. Marks (grocer), John W. Daniel (grocer), and Fong Kee (laundry). Many merchants had sufficient warning of the impending flood and moved their merchandise from the ground floor and lower shelves to higher shelves and upper floors.

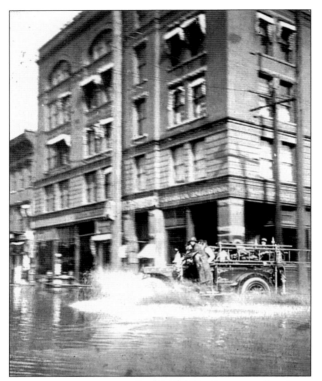

A fire engine rushes past the Dyer Building during the 1912 flood. The Dyer Building was located at the corner of Broad and Eighth (Jackson) Streets. (Courtesy of Joseph M. Lee III.)

Boats solve transportation problems. These gentlemen take a trip down the 900 block of Broad Street. Boats like these were used to rescue people or take provisions to those residents who were trapped. This postcard was sent to Mrs. A.A. Mills in Massachusetts. The message reads, "This will give you a little idea of our flood last Saturday and Sunday. This is the principle business street." (Courtesy of Joseph M. Lee III.)

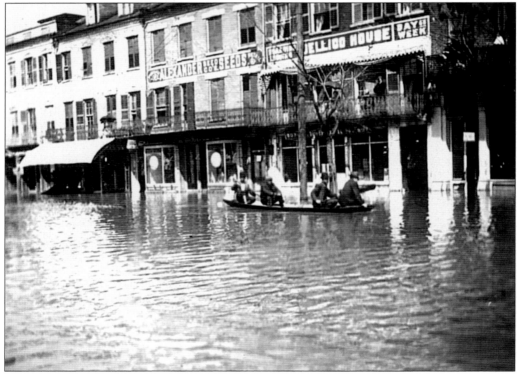

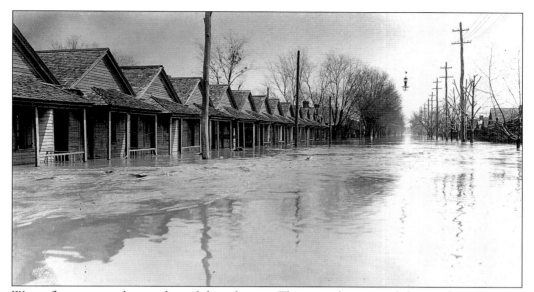

Water flows up on the porches of these homes. The exact location of this residential area is unknown, but it is believed to be along either Reynolds Street or Jones Street. The 1913 flood area was concentrated to the northeast.

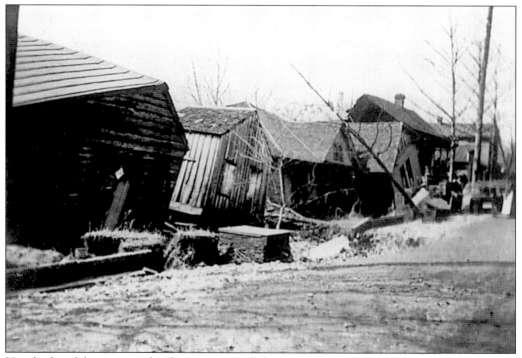

Hundreds of homes in the lower parts of the city, nearest the river, were completely under water. Those homes located near the Savannah River, in the Market Street area, were hardest hit. The swift current toppled some homes off their foundations. (Courtesy of Joseph M. Lee III.)

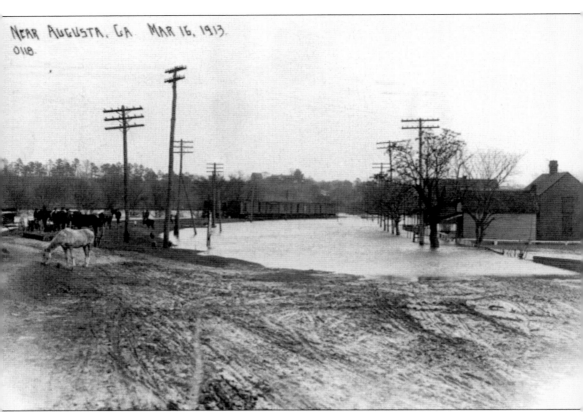

The level of floodwater during the 1913 flood did not reach that of the 1912 flood. The back of this card, sent to Elizabeth Richardson in Providence, Rhode Island, reads, "This is a picture showing how the river rose and overflowed to country above here last week." (Courtesy of Joseph M. Lee III.)

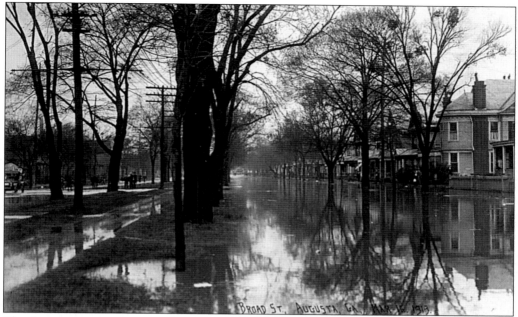

The deepest water was primarily in the eastern end of Broad Street. This postcard, published by W. Reid Kirkland, provides a view looking west down Broad Street along the 1400 Block. The 1913 flood was nowhere near as damaging as the one the previous year and most of the downtown merchants received sufficient warning to protect their stock.

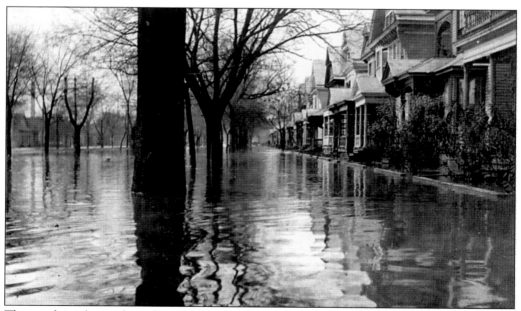

This residential area along the 1400 Block of Broad Street was one of the hardest hit during the flood. This area contended with overflow from the canal, backed up sewer lines, and the rising river. Residents either moved their furniture upstairs or elevated it the best they could.

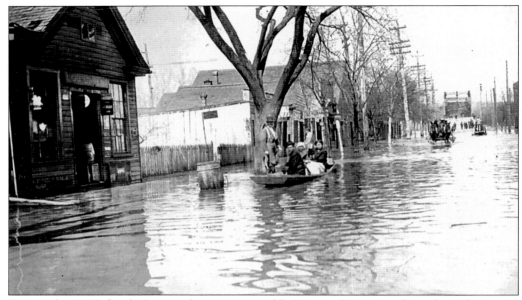

During the 1913 flood, Augusta began to resemble Venice. Many people took to the water-covered streets in boats as the driest travel alternative. This postcard shows Thirteenth Street, between Reynolds and Jones. The steel construction of the Thirteenth Street Bridge stands in the background. The wooden structure on the left is Lou Chuen's Grocery.

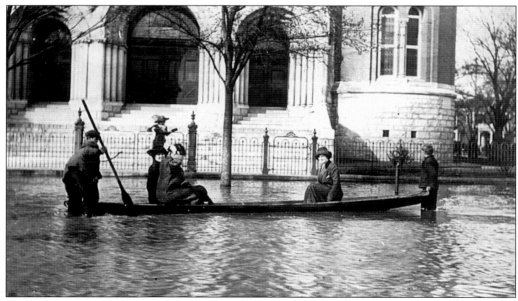

These ladies prefer boating to other modes of transportation. They smile for the camera as they float down Thirteenth Street in front of Sacred Heart Catholic Church.

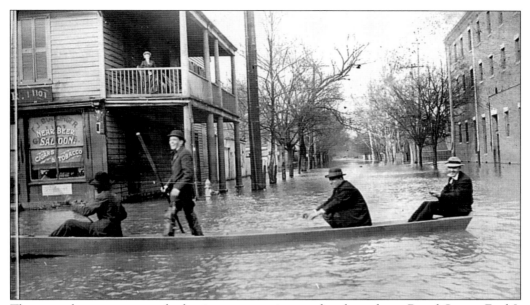

These gentlemen appear to be having a merry time as they boat down Broad Street. Fred J. Ballinger's Near Beer Saloon was located at the corner of Eleventh and Broad Streets. The man standing in the boat has been identified as Vic Markwalter.

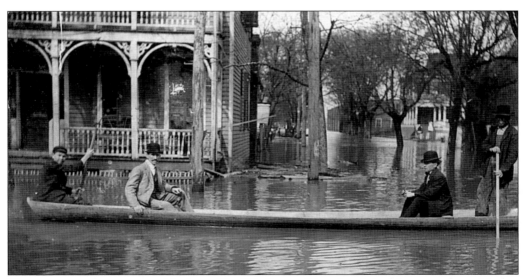

These two gentlemen get a ride down Twelfth Street. The view is looking west down Market Street. The house on the corner at 35 Twelfth Street belonged to Hester Wilkinson. This image has previously been misidentified as the 1908 flood.

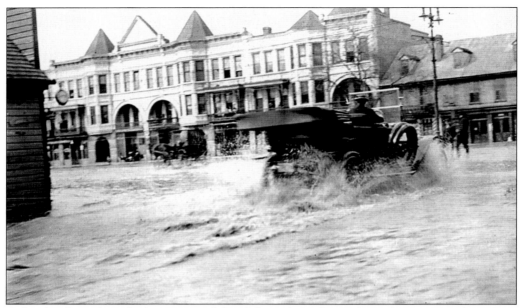

A few hardy souls with their automobiles did not let a few inches of water stop them from traveling about. This gentleman speeds down what was known as the Silver Block. The Silver Block encompassed the 1200 Block of Broad Street.

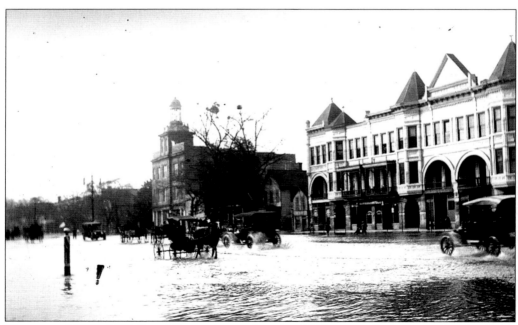

The area of 1201–1239 Broad Street depicted in this 1913 postcard was known as the Silver Block. In the background, the fire department headquarters can be seen. Located at 1259 Broad Street, this building was designed by G. Lloyd Preacher and opened in May 1910.

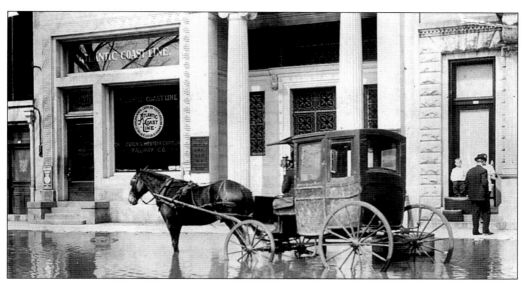

This horse waits patiently in the water while his master conducts his business. The carriage is parked outside of the Atlantic Coastline Railroad Co. office and the Charleston Western Carolina Railway office. These offices were located at 829 Broad Street.

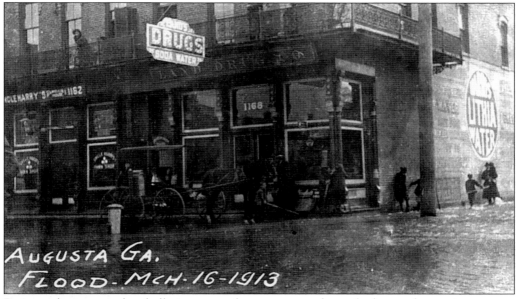

Due to advance weather bulletins, most downtown merchants had enough warning to save their merchandise so the following Monday it was business as usual without a great deal of clean up. There were only a few cellars that needed to be pumped out. More than 75 percent of the mercantile houses had not even been touched. This postcard provides a view outside Lands Drug Co. at 1168 Broad Street. Robert J. Land was the proprietor and druggist.

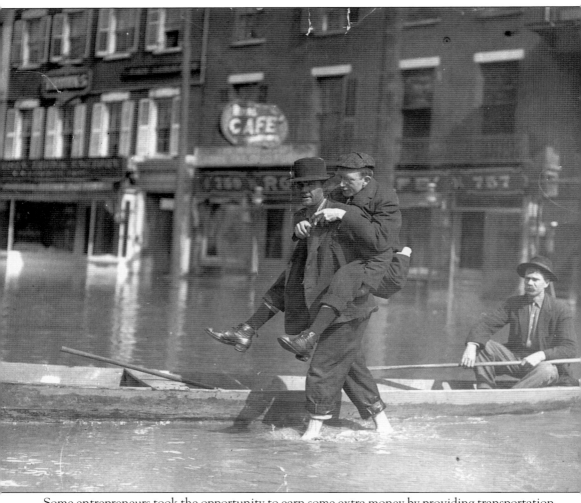

Some entrepreneurs took the opportunity to earn some extra money by providing transportation during the worst of the flood. Whether by boat or piggyback, a ride could always be found so that pedestrians did not have to get their own feet wet.

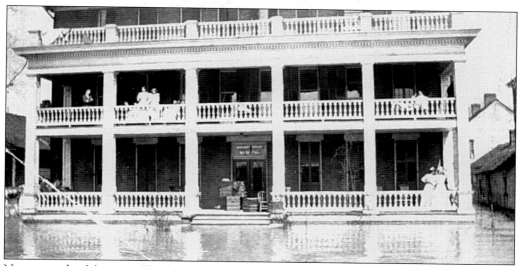

Nurses at the Margaret Wright Hospital step out on the veranda to investigate the rising floodwater. The hospital, located at 1351 Greene Street, opened in 1910 and closed in 1930.

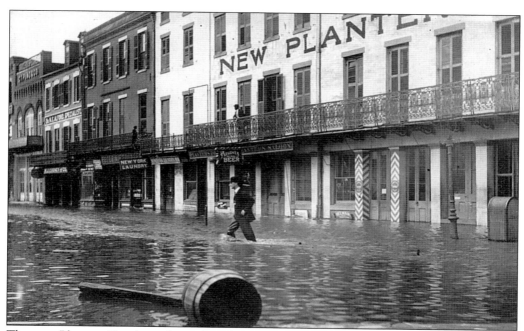

The new Planters Hotel was located at the corner of Broad and Macartan Streets. The hotel boasted its own saloon and hosted the Augusta Brewing Co. The New Planter's Hotel was a remodeled version of the old Planter's.

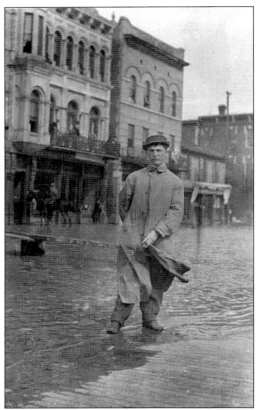

This gentleman pauses to pose for a photograph. He is standing on the north side of the 1000 Block of Broad Street. The building to the left behind him is the Slusky Building. David Slusky established the business there in 1895. The business manufactured galvanized iron cornice and architectural work. Besides the front of his own building, Slusky made the fronts for the Silver Block, the Chronicle Building, the King Building, and St. John's Church.

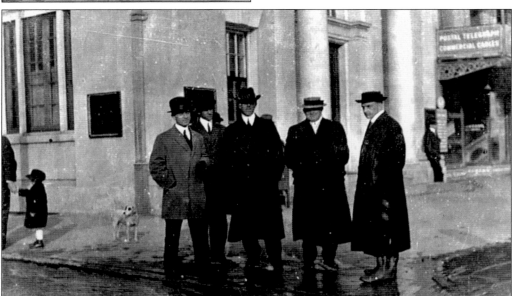

These gentlemen gather on the corner of Eighth and Broad at the Union Savings Bank (769 Broad). The floodwater is beginning to recede, but the gentleman on the right continues to wear his rubber boots.

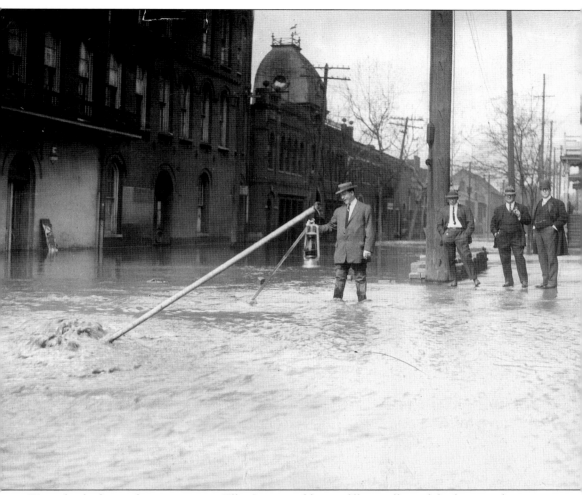

Water backed out of sewer pipes on Ellis Street and began filling cellars of the business houses nearby. This photograph provides a rare view down Ellis Street, just off Eighth Street. The large building on the left is Odd Fellows Hall. Odd Fellows Hall was a fraternal order and was located on the second and third floors. The building on the right with the steps housed city offices and police headquarters.

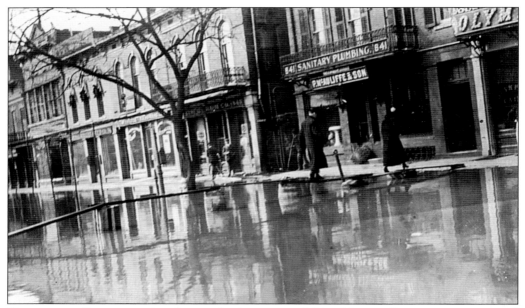

Temporary walkways were rigged across the deeper areas. Most of these walkways were constructed out of wooden planks and crates. The walkway seen here crosses to the Olympia Café, located at 835–837 Broad Street. Next door at 841 was T.G. McCuliffe and Son, Plumbing, Steam, and Gas Fitting. The walkways were not always the most stable and not a guarantee for the driest travel. Several pedestrians took an unexpected dive into the murky water while trying to cross.

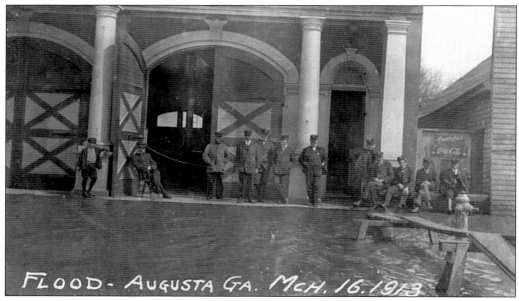

Firemen gather in front of the fire department headquarters. This building, at 1259 Broad Street, opened May 19, 1910. Notice the temporary walkway constructed out of boards and saw horses.

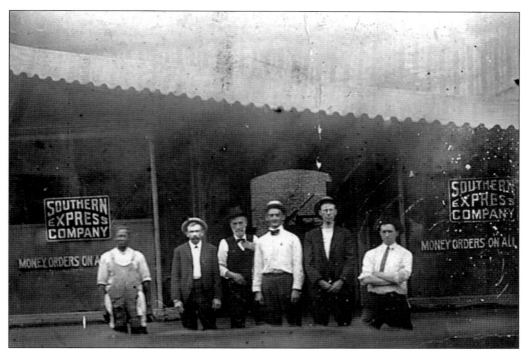

Merchants or other businesses occupied the ground level of most of the buildings downtown. The upstairs levels were usually rented out as apartments. This postcard shows a group of men standing in front of the Southern Express Co., located at 318 Eighth Street, between Ellis and Greene.

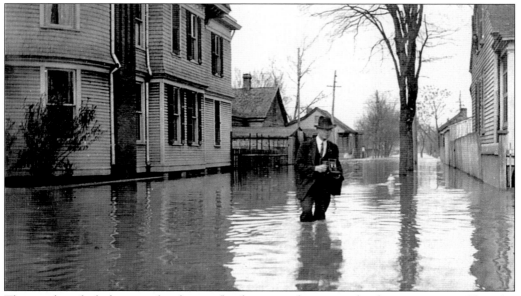

This unidentified photographer braves floodwater to document the disastrous event. Here, he becomes the subject as he stands at the intersection of Broad and Fourteenth Streets. Some of his photographs may be the images we study today.

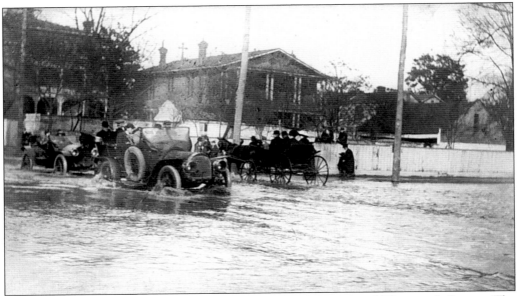

This 1913 flood image surveys the northeast corner of Greene and Thirteenth Streets. The two buildings in the background are Sacred Heart Convent (left) and Sacred Heart Academy (right). The Sisters of Mercy operated the Sacred Heart Convent.

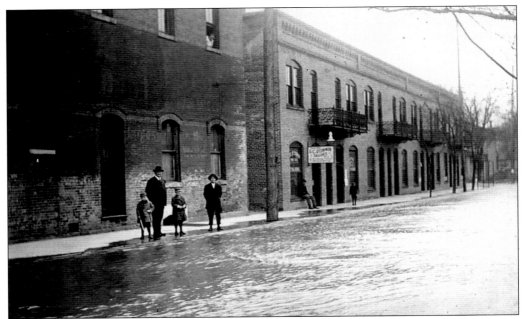

The 1913 flood caused relatively little damage to the business area of Broad Street due to advance warnings and the quick preparedness of shopkeepers. This postcard looks south down Twelfth Street. The sign in the image is for O'Connor Tailors at 210 Twelfth Street, owned by Grover C. O'Connor. This shop provided dry-cleaning and pressing. The large building in front is the old Brisban Building, which is still on Broad Street. The site of O'Connor Tailors is now a parking lot.

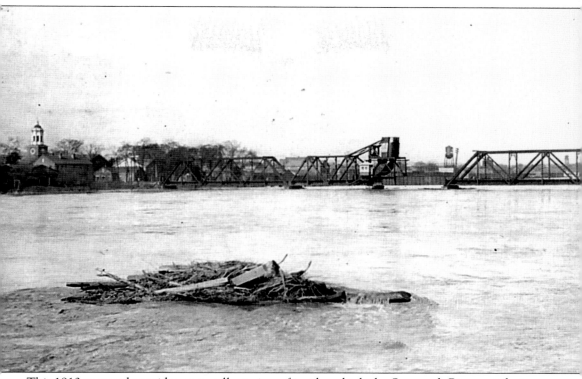

This 1913 postcard provides an excellent view of just how high the Savannah River got during the flood. The water can be measured against the Sixth Street Railroad Bridge. St. Paul's Episcopal Church appears at the left.

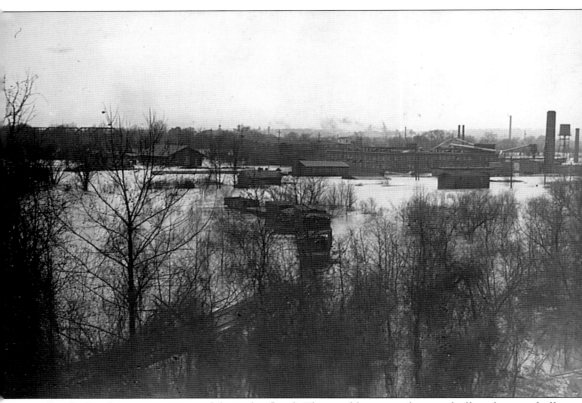

South Carolina was not spared from the flood. The muddy water almost wholly submerged all the houses on the riverfront in Hamburg, South Carolina. This postcard shows a rare view of flood damage to the North Augusta area. The low-lying area at the end of the Thirteenth Street Bridge was covered with water. Several train cars were left abandoned. The bridge seen in the background is actually the Sixth Street Railroad Bridge downstream.

Five

FIRES OF 1899

During 1899, the 800 block of Broad Street suffered two devastating fires. The first began on the night of June 7, reportedly started by an explosion caused by oil stored in Davenport and Phinizy and Alexander's drugstores. Winds once again played a role and carried embers onto Reynolds Street. This fire was stopped by the firewall in the Dorr Building. The second fire that year started at 3 a.m. on December 10 in the J.B. White Building. The fire consumed the block from the Dorr Building to the Arlington Hotel. It burned through buildings very quickly, jumping to Ellis Street and burning the livery stables. The fire department once again relied on the firewall in the Dorr Building to stop the blaze from spreading east.

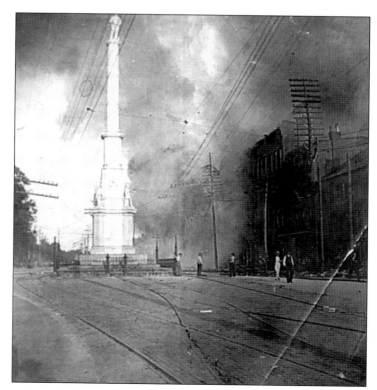

It is believed that an explosion was caused by barrels of oil stored in the Davenport and Phinizy and Alexander's Drug Store. This photograph provides a long view of the fire there on June 7, 1899. The June 8 *Augusta Chronicle* proclaimed it, "Augusta's Greatest Fire."

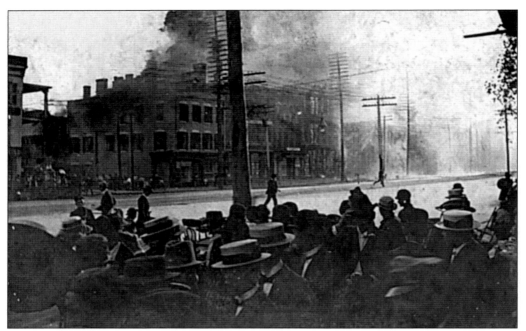

This photograph shows the fire burning at its highest point at the Montgomery Building. A steam fire engine appears in the background on the left. The June 8 *Augusta Chronicle* stated, "While the fire is one involving serious losses and great interference with the business of popular firms. We think it opens the way to great and valuable improvements by the public spirited and wealthy men who won the property and we confidently predict that good will result to Augusta from the ill wind which swept the flames over valuable property yesterday."

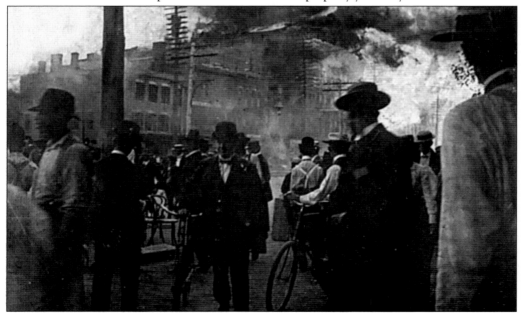

Citizens of Augusta mill around and watch as the fire progresses in the Montgomery and King Buildings. Winds carried embers to the cotton district on Reynolds Street.

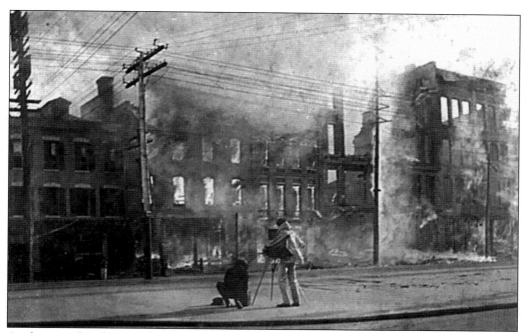

A photographer braves the heat and smoke to capture the June 1899 fire on film. This photograph shows how the fire destroyed the buildings, leaving behind only the facades. Some burning poles interrupted telephone communication. Western Union Wires also burned.

The fire finally began to burn out at Seventh Street. The heat of the fire was so intense that it cracked and burned the asphalt. The fire stopped in the Dorr Building. There was much consideration by the city and property owners to determine what would be built in place of the demolished structures. In the end, a contract was awarded to T.D. Brown to build a five-story office structure for the sum of $29,000.

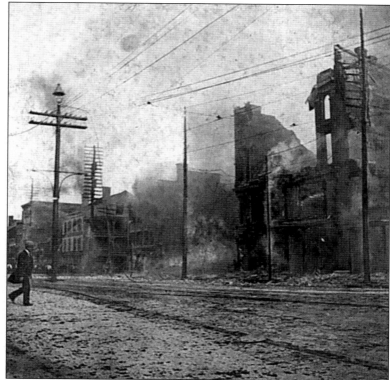

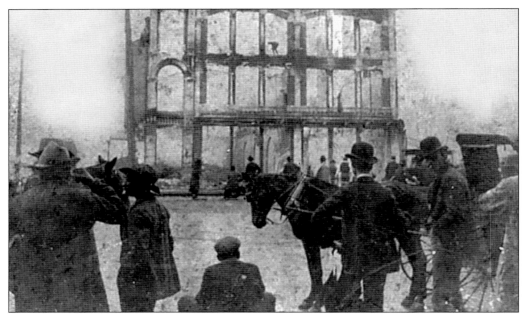

On December 10 the fire started in the J.B. White Building at 738 Broad Street. The other portion of that building was the Albion Hotel. C.D. Cone discovered the fire that burned all the way up Eighth Street, leaving only the Dorr Building standing. The remains seen here are those of the Masonic Building.

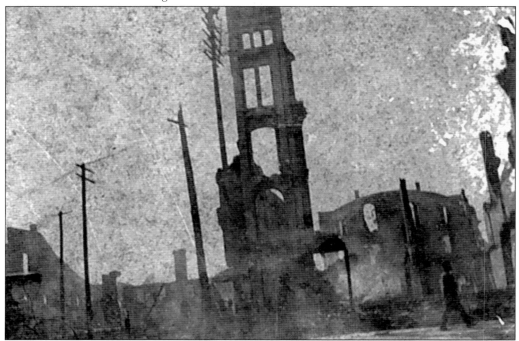

Unsafe walls of the Masonic Building were dynamited to prevent the walls from accidentally falling. The buildings burned very quickly. Many people blamed this on the fact that the buildings were not inspected and contained no firewalls.

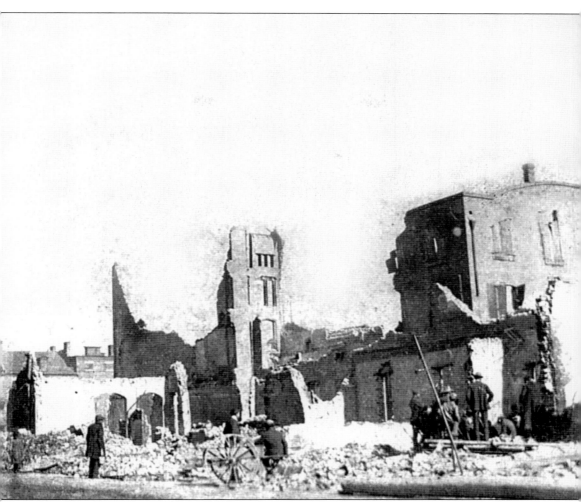

This photograph shows a rear view of the remains of the Masonic Building and the Arlington Hotel. The citizens of Augusta opted to turn the disaster into opportunity to improve the city and modernize it when they rebuilt. The Albion Hotel was built to replace the Arlington.

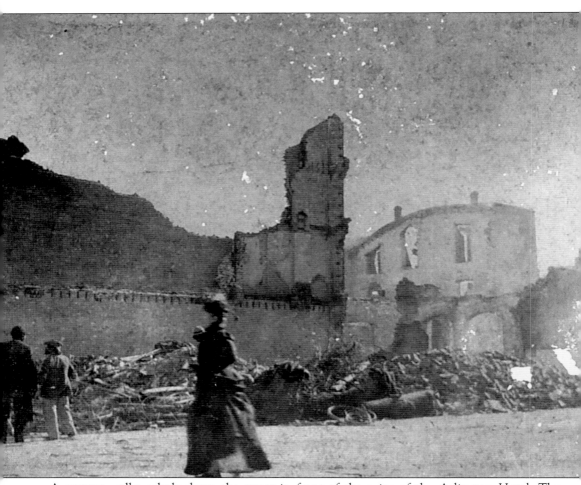

A woman walks calmly down the street in front of the ruins of the Arlington Hotel. The hotel was located at the southeast corner of Broad and Eighth Streets. The hope was that an up-to-date hotel would be built on the site of the destroyed Arlington Hotel.

Six

GREAT FIRE
OF 1916

High winds, low water pressure, and inadequate fire equipment all played a role in the devastation caused by the March 22–23, 1916 fire. The fire originated in the Dyer Building and completely engulfed an area of one-quarter square mile, or approximately 160 acres. Property loss was estimated at $4,250,000. Neighboring cities Atlanta, Macon, Columbia, and Savannah were quick to send aid in the form of fire equipment and firemen. A committee on Public Safety formed to raise money for relief. Once the fire department conquered the fire, clean up and removal of debris began immediately. On a wider scale, citizens made plans to get downtown Augusta up and running again. Much of the town returned to its pre-fire form.

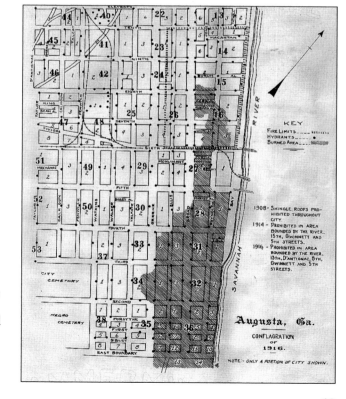

The 1916 fire burned approximately 25 city blocks. This map, included in the 1916 Conflagration Report, illustrates the area that was burned. The key points out the fire limits and hydrants. One of the criticisms after the fire was that the water pressure was too low and not adequate to fight the fire.

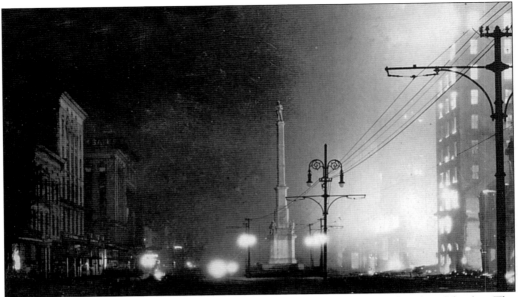

This image looks west down Broad Street along the 700 Block during the height of the fire. The fire chief had attempted to check the fire at the fireproof buildings (the Empire and Chronicle Buildings) to divert the flames to the river. However, these attempts failed due to the wooden-framed windows in these buildings and the unprotected openings in a three-story brick structure behind the Chronicle Building.

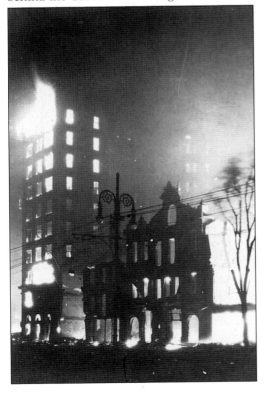

Flames shooting out of the upper windows of the Chronicle Building are shown here. The remains of the Commercial Club sit quietly beside the blaze. The 10-story Chronicle Building was gutted and the machinery wrecked, yet the paper still managed to put out a two-page edition filled with details and information.

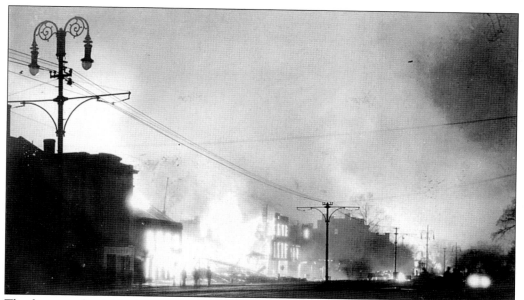

The fire spread quickly due to strong winds. This postcard provides a look down the 600 Block of Broad Street during the height of the fire.

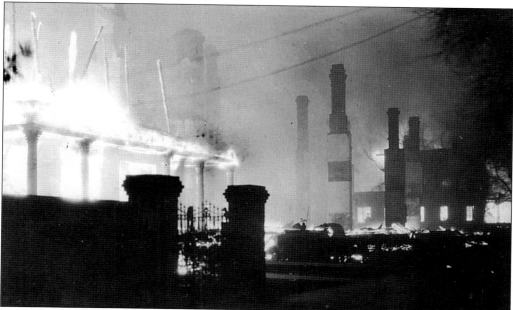

The areas hit the hardest by the fire were those occupied by homes. The area bracketed by Fourth, Greene, Bay, and East Boundary Streets lost many homes. Two main reasons for the destruction were the high winds and the use of shingle roofs. After repeated urgings from the chief of the fire department, the city adopted an ordinance prohibiting shingle roofs. In 1914, this ordinance was amended to allow for the use of wooden shingles except in the area bounded by the river, Gwinnett and Fifth Streets. After the fire, the building code was once again adapted to prohibiting new wooden shingle roofs inside the city limits. This image shows how quickly a wooden structure could be reduced to rubble.

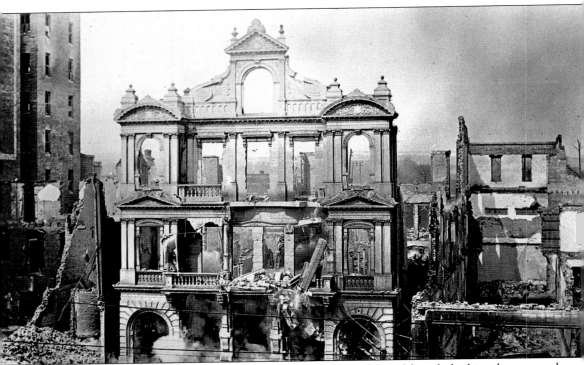

The front facade of the Commercial Club was left standing, although looking beaten and battered. Day and Tannahill Hardware Supplies occupied the ground floor of the building. The two following images show the walls being dynamited.

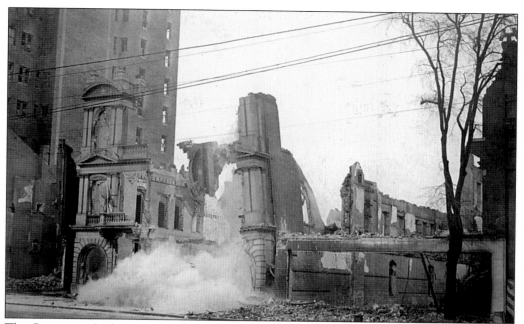

The Commercial Club was a center for business life of the city. It was considered modern and up-to-date. All modern conveniences known to club life were available to the members. The membership was large and was a great factor in public life. (Courtesy of Joseph M. Lee III.)

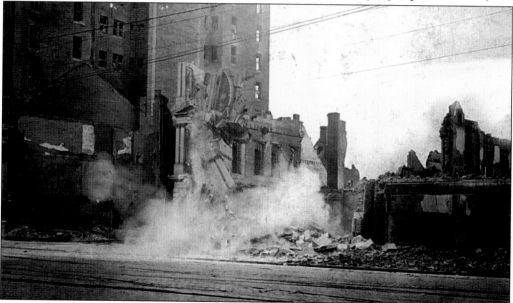

Once the embers were cold, crews began work dynamiting the walls of the Commercial Club. The walls were torn down quickly, so they would not crumble and fall on their own, possibly injuring a bystander. The Commercial Club was located at 727 Broad Street. In addition to its billiards, cards, and reading and lounging room, the club also offered a magnificent dining room that could serve 100 guests. Two photographs were taken as the wall came down. (Courtesy of Joseph M. Lee III.)

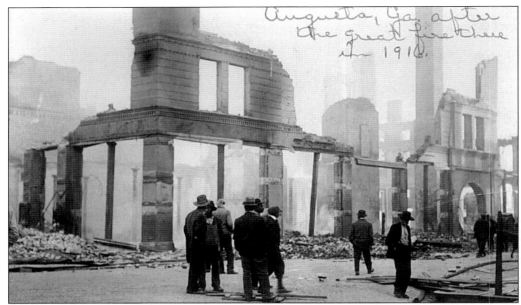

An interval between the start of the fire and its control covered a period of 10 hours and 40 minutes. The following morning, only skeletons of buildings remained. This image shows all that was left of the Dyer Building, where the fire originated. The Dyer Building was considered a fire hazard. The building contained a pressing and cleaning shop, a restaurant, a barbershop in the basement, mercantile stores on the first floor, and offices above. (Courtesy of Joseph M. Lee III.)

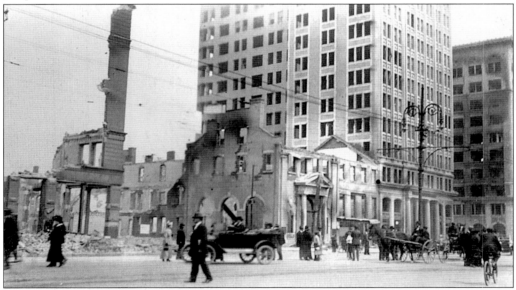

This photograph shows a long view of the center of the fire damage. The Dyer Building is on the left. This area comprised the business center of Augusta. The Chronicle Building, seen at the right, was completed in November 1914. When completed, the building was touted as possessing all modern conveniences and equipment. This photograph was taken by Murphy and Farrar, Inc.

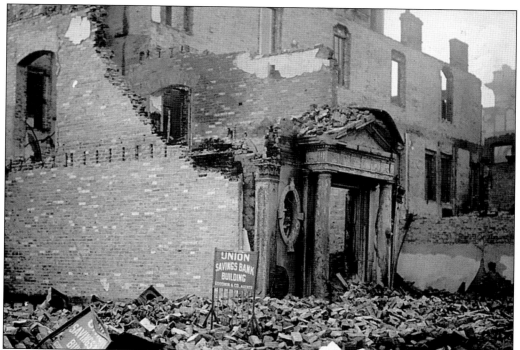

The postcard depicts the remains of the side entrance of the Union Savings Bank Building. This building was located at the northeast corner of Eighth and Broad, across from the Dyer Building where the fire started. The Union Savings Bank had moved into this building with much fanfare in 1910. A headline from the January 30, 1910 *Augusta Chronicle* read, "Union Savings Bank Moved Into Its Handsome New Home Yesterday—Exquisite Details."

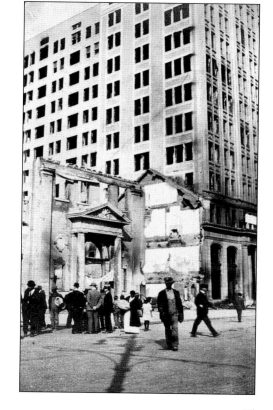

Men gather around the front facade of the Union Savings Bank, located at 769 Broad Street. Murphy and Farrar, Inc. produced this image.

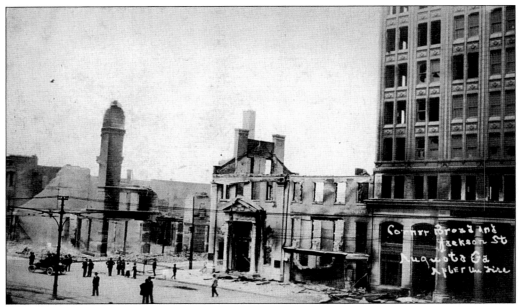

This photograph offers a wide view of the Union Savings Bank remains. The large building next to it is the Empire Building. The Empire Life Insurance Co. constructed the Empire Building in 1913. The building, later renamed the Lamar Building, was built with fireproof material. The outside of the building survived, however most of the interior was gutted. Due to financial setbacks, the building was not finished and did not open for use until 1918.

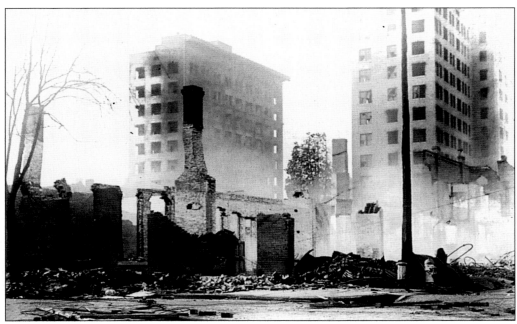

Judge William H. Barrett headed a committee on Public Safety, consisting of 15 leading citizens, appointed to raise $10,000 for immediate relief. This image provides a rear view of the Chronicle (left) and Empire (right) buildings, looking from Cotton Row towards Broad Street.

Another photograph produced by Murphy and Farrar, Inc. shows the remains of the Empire and Chronicle Buildings. A trolley car stops on the street in front of the Chronicle Building.

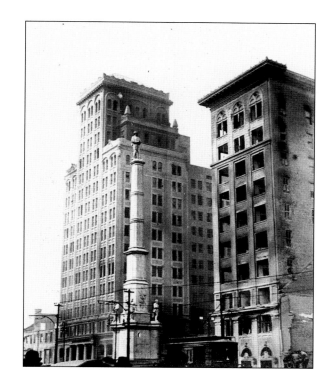

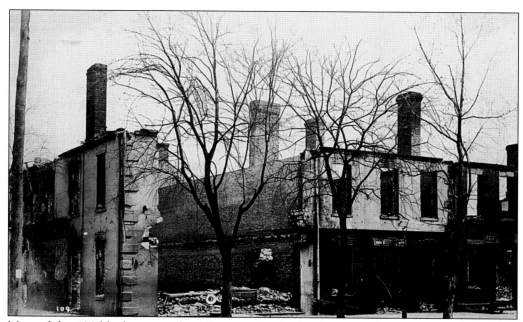

Most of the 400 block was residential except for the last few lots. This view was taken at the corner of Fifth and Broad Streets. These buildings held businesses operated by local African Americans. At the time of the fire, grocer E.E. Carroll occupied the corner building (473 Broad). (Courtesy of Joseph M. Lee III.)

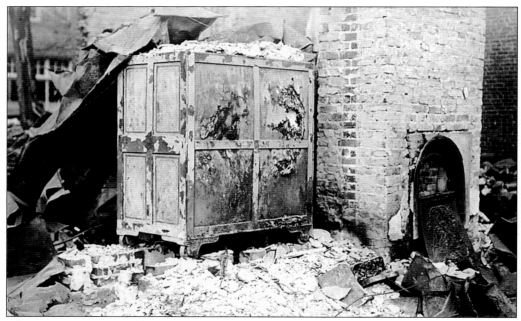

This image proves that some things are "fireproof." This safe was found among the rubble. It is unknown if the contents survived unscathed. (Courtesy of Joseph M. Lee III.)

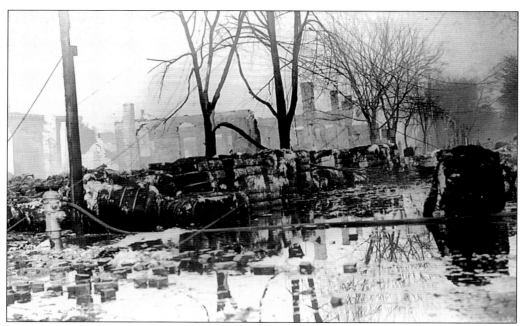

The loss of cotton was estimated at 20,000 bales at a value of $1,200,000. This postcard provides a view of Cotton Row, along the 700 block of Reynolds Street. Much of the cotton was burned in the fire, but it was also ruined by water.

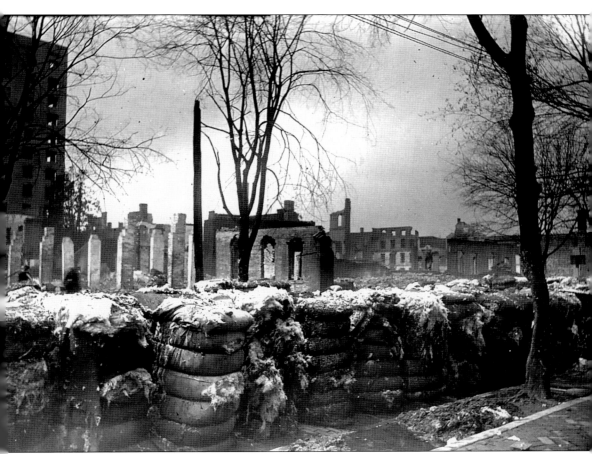

Cotton warehouses, although brick, did not have firewalls. Cotton was mainly stored in the open street. "At times of congestion practically all the streets northeast of Broad from 6th to 10th are so choked with cotton bales that vehicles can scarcely pass," reported the *Conflagration*. It was reported that at the time of the fire, Reynolds Street was in this condition from Seventh to Ninth. A third of the loss of cotton occurred here. Once the cotton ignited, fireman could not attach to hydrants in this area. This photograph is looking west along Cotton Row. A portion of the Dyer Building remains in the background.

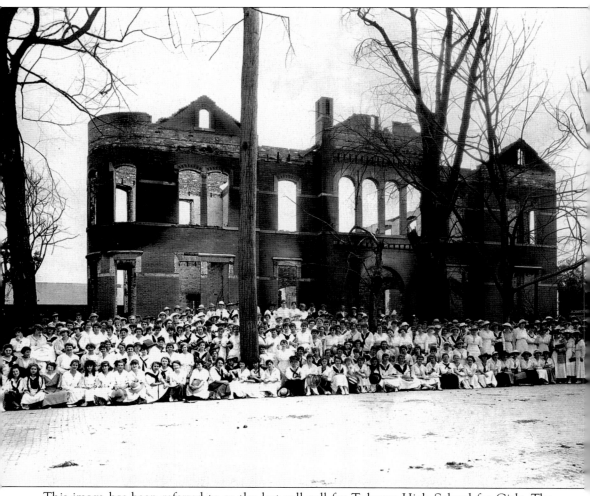

This image has been referred to as the last roll call for Tubman High School for Girls. The building burned completely on the night of March 22, 1916. Tubman High School was located at 711 Reynolds Street, surrounded by cotton warehouses. Emily H. Tubman provided the building in 1874. The building was used to house the First Christian Church until Mrs. Tubman provided funds for a new church on Greene Street in 1876. From 1916 to 1918 Tubman High School operated out of a building on Telfair. The new Tubman High School, at 1740 Walton Way, opened on February 18, 1918.

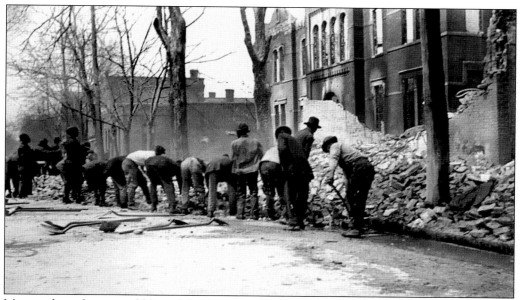

Men work to clean up rubble and the remains of Tubman High School. Fire debris, shaky walls, and tottering chimneys were removed and cleanup was undertaken at once. Cleaning squads, numbering in the hundreds, gathered.

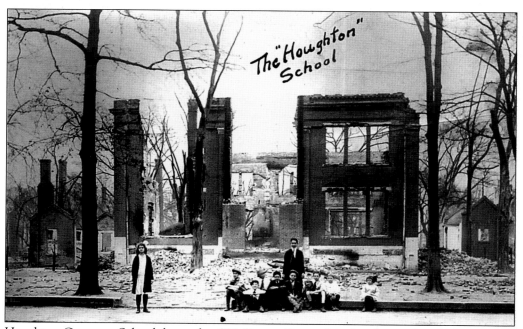

Houghton Grammar School, located at 329 Greene Street, faired no better than Tubman High School. This school, bequeathed to the City of Augusta by John W. Houghton in addition to a large trust, provided a free education for poor children. After the fire, the school was rebuilt at 333 Greene Street at the cost of $60,000, along with a memorial to Houghton.

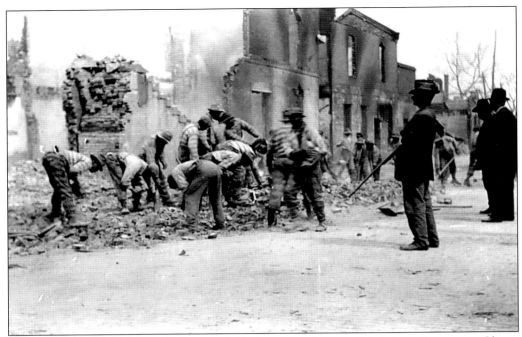

The city used convicts and all other available bodies to clean up debris from the streets. Clean-up work began as soon as possible. An estimate of losses was reported at $4,250,000, and 141 businesses and 541 dwellings were destroyed.

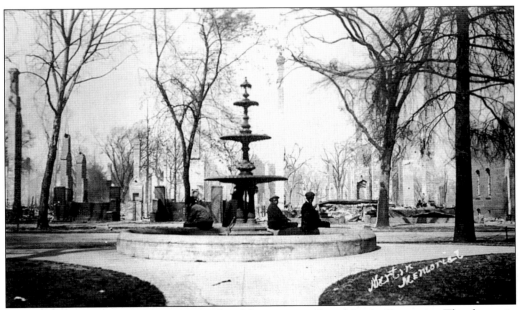

Some gentlemen take a rest amongst the debris surrounding Martin Fountain. The fountain was a memorial to Mayor Alfred M. Martin Jr., who died February 22, 1901. The fountain was located in the middle of the street at 312 Greene, in front of what was formerly Mayor Martin's home.

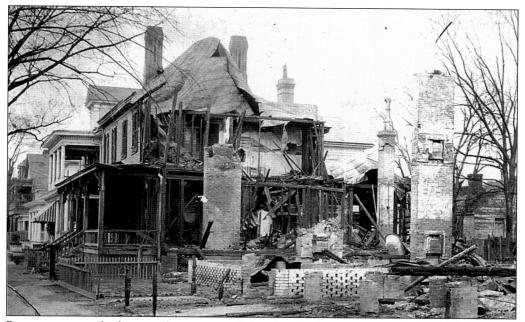

Reports were made that two firemen were injured at the house seen in this image by a falling chimney. Just before dawn, the wind subsided and the fire was stopped at 250 Greene Street, the home of George F. Lanback. Lanback was the Richmond County Treasurer. It is doubtful that Lanback's home is the one in this image.(Courtesy of Joseph M. Lee III.)

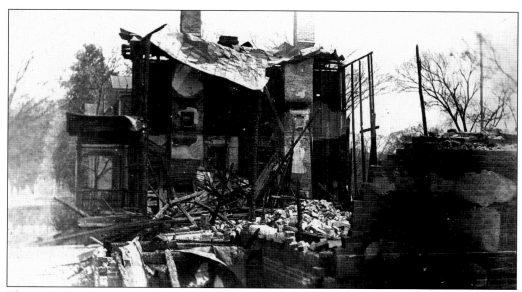

The exact location of this house is unknown. Fortunately, the firemen were able to get the fire under control.

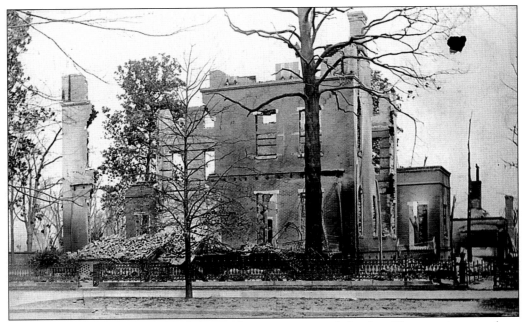

Just like wooden structures, brick homes became victims of the fire. The remains seen here are those of the Barrett House, the family home for three generations, owned by Thomas Barrett Jr. Barrett was a cotton factor and vice-president of Barrett and Co. The home was located at 347 Broad Street.

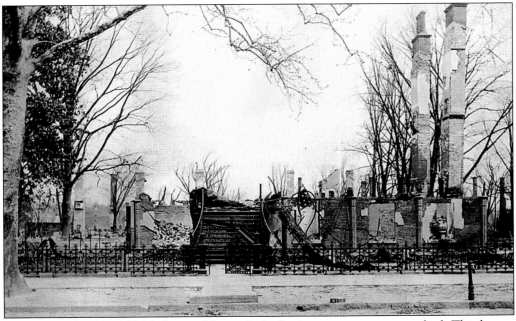

Little was left of the old McGowan Home. Only the iron steps seem untouched. This house, located at 325 Broad Street, was owned by F.L. Marshall at the time of the fire.

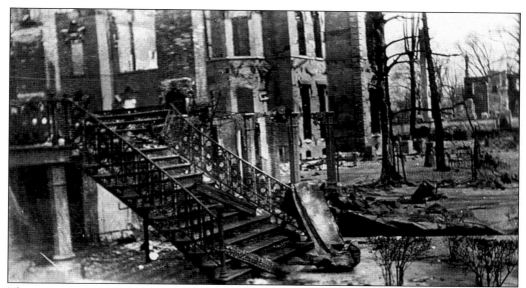

This view of the McGowan house provides a close-up of the damage. The image also shows the home next door at 317 Broad Street, referred to as the Gould house.

The McGowan home was one of Augusta's most beautiful before the tragic fire on March 22–23, 1916. This house was the residence of James F. McGowan c. 1908. McGowan was the president and general manager of Georgia Compress Co., as well as a cotton merchant with Inman and Co. At present, this area is the site of Broadway Apartments. The postcard was published by S.H. Kress. (Courtesy of Joseph M. Lee III.)

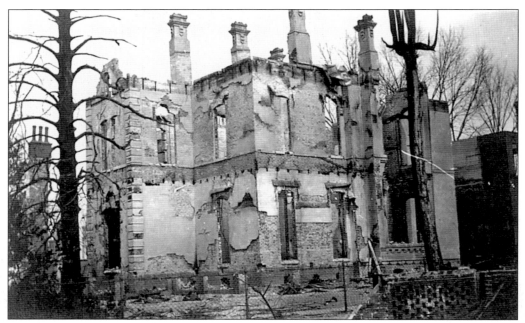

Another of Augusta's handsomest homes that was destroyed by the fire was the Gould House. At the time of the fire, the Gould House was owned by J.G. Jeffries.

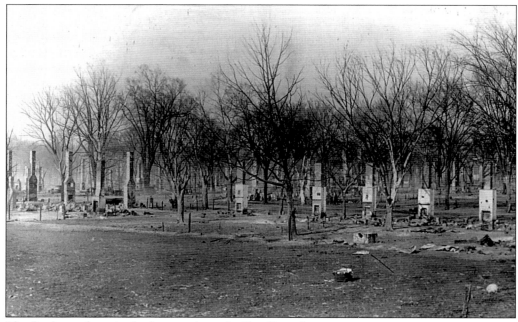

The fire burned out in the houses along the East Boundary.

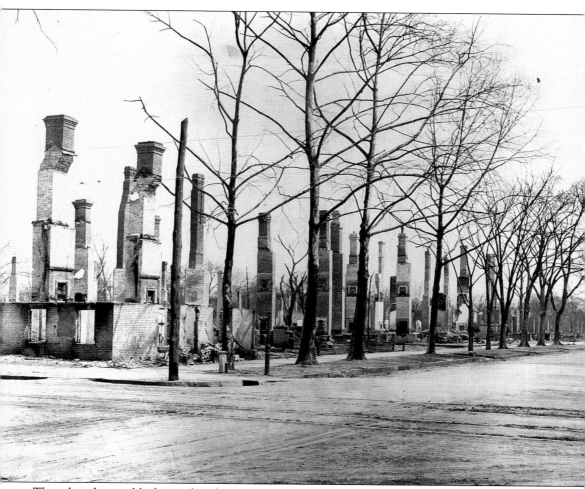

Though indiscernible from other damaged residential areas, this photograph is of the lower area of Greene Street, looking east from Third (Lincoln) Street. The trolley tracks on Lincoln Street led to the city car barn. The house on the corner belonged to J.W. Johnson. Warren, a well-known Augusta photographer, took this photograph.

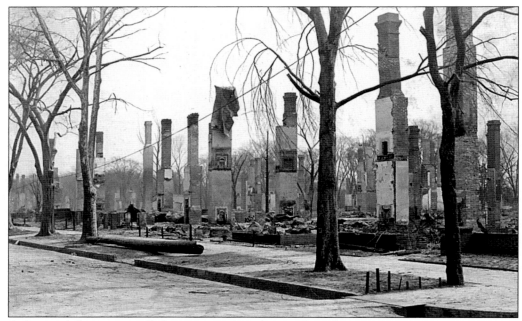

A forest of chimneys is all that remained in this residential area. These houses were located along Ellis Street near the corner of Third (Lincoln) Street. (Courtesy of Joseph M. Lee III.)

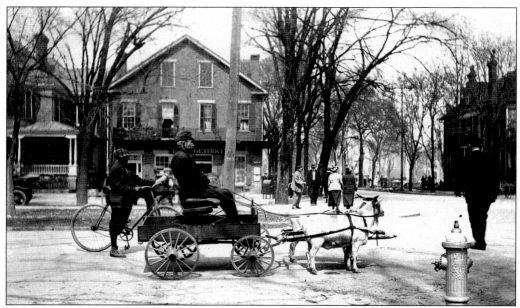

A gentleman in his goat cart stops at the intersection of Fourth and Greene Streets. Although this area seems untouched by the fire, the remains of burned houses can be seen down Fourth Street. The building (401 Greene) on the corner was operated by Fred Gehrken, a grocer.

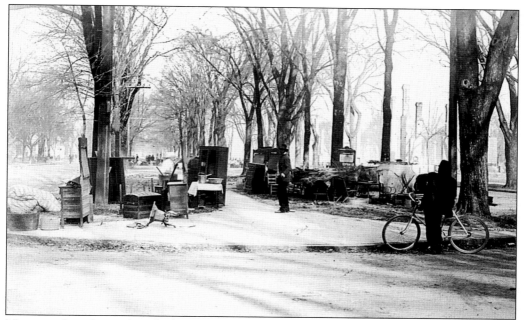

Many residents knew that the burning of their home was inevitable. Trying to save what they could, many moved furniture and household belongings to the middle of the street. They remained awake the entire night to watch over their possessions. This view is in the middle of lower Greene Street.

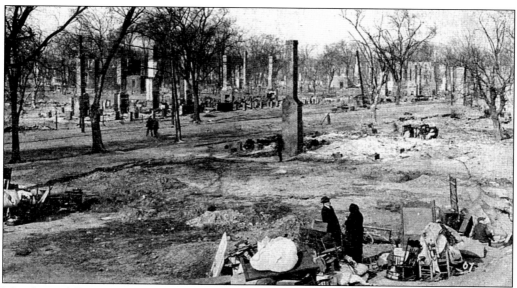

Murphy and Farrar, Inc. published a booklet entitled *Fire Scenes* shortly after the fire. This postcard was printed from one of those images. Three thousand citizens (600 families) were left homeless by the fire. Before their homes were gone, many people saved what cherished possessions they could.

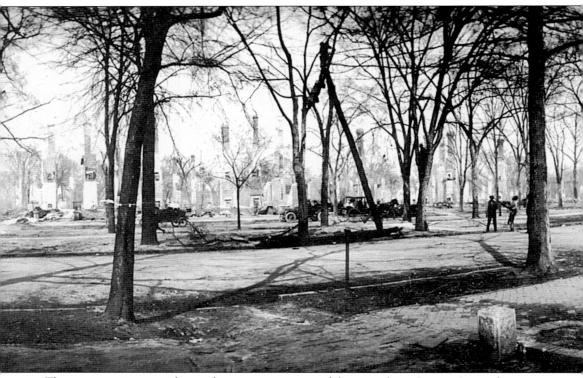

This panoramic postcard provides a sweeping view of the area along Greene Street that was

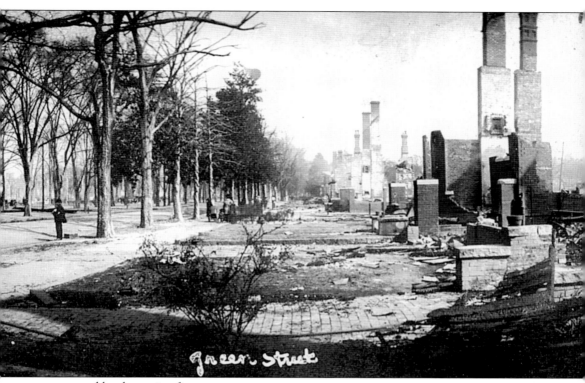

Green Street

encompassed by the raging fire.

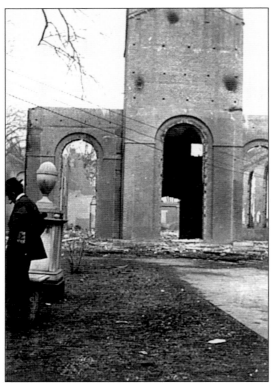

St. Paul's Church, located at 605 Reynolds Street, is on the National Register of Historic Places. The current Georgian Colonial Building was completed in 1919. This photograph provides a view of the front of the church after the fire. This photograph was produced by Murphy and Farrar, Inc.

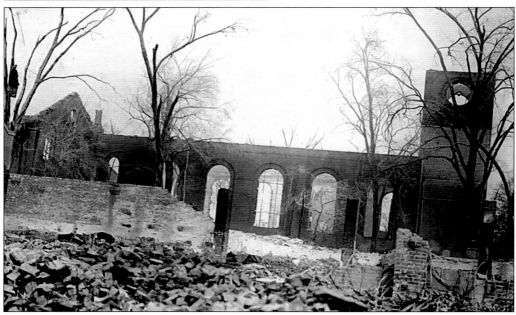

St. Paul's Episcopal Church, at 605 Reynolds Street, has a long history in Augusta. The third structure to house the church was built in 1819 and destroyed in the Great Fire. The church was rebuilt in 1918 in the same location, as an exact replica of the third building. The original church was named for the Church of England's historic St. Paul's Cathedral in London.

Seven

LESSER-KNOWN DISASTERS

The disasters mentioned here are not minor, but they are not as well documented as the others were. This chapter contains images of the 1902 flood, the 1929 flood, and the 1921 fire. The 1902 flood occurred during early March. Once again, the low-lying areas and those east of Broad Street were the hardest hit. The floodwater in September of 1929 was very heavy. The water caused a manageable breach in the levee about five miles below Augusta. The city cemetery and the African-American cemetery closed to burial purposes for over a week as backwater covered them with several feet of water. In 1921, fire struck Broad Street, starting at the corner of Eighth and Broad. The fire destroyed the Johnson, the Harrison, and the Chronicle Buildings, as well as the Albion Hotel.

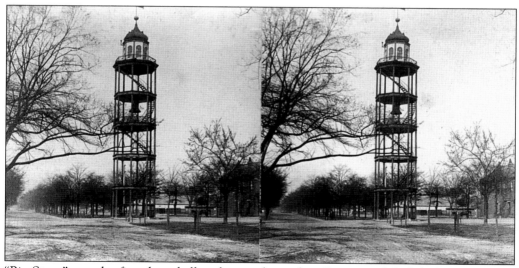

"Big Steve" was the fire alarm bell and tower located at Greene and Eighth (Jackson). The tower, named for city councilman Stephen Heard, was used as a lookout and an alarm was sounded from there. The alarm was sounded once for district one, twice for district two, etc. This stereo view was produced by Usher's Stereo Views. (Courtesy of Joseph M. Lee III.)

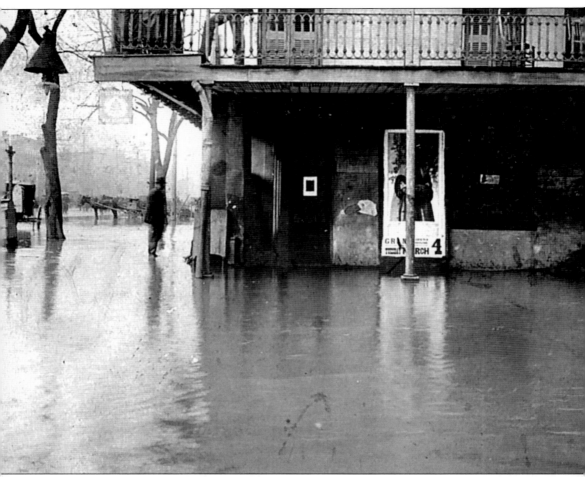

On March 1, 1902, Augustans faced the threat of flooding. Some predicted that the Savannah River would reach 34 feet. By 3 p.m., the water reached the north side of Broad Street. Merchants dammed up their doors and removed goods from their cellars. This photograph shows the Planters Hotel surrounded by water at 5 p.m. The Planters Hotel office, barbershop, restaurant, and bar all flooded. The Planters Hotel was located at the corner of Broad and Macartan Streets.

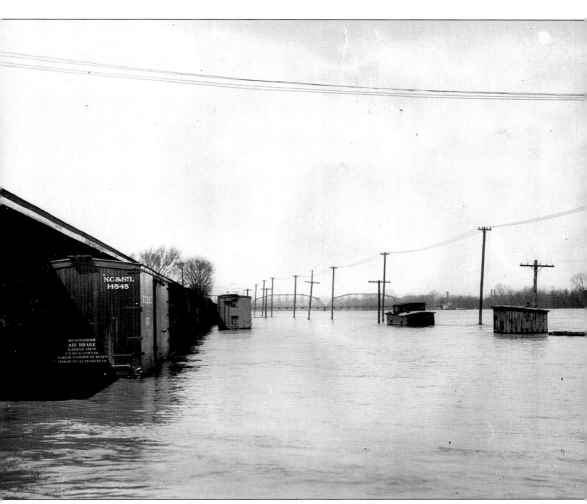

The river rose and surrounded everything within its reach during the 1929 flood. In this photograph, the river overflows its banks. The North Augusta Bridge (Thirteenth Street) can be seen in the background.

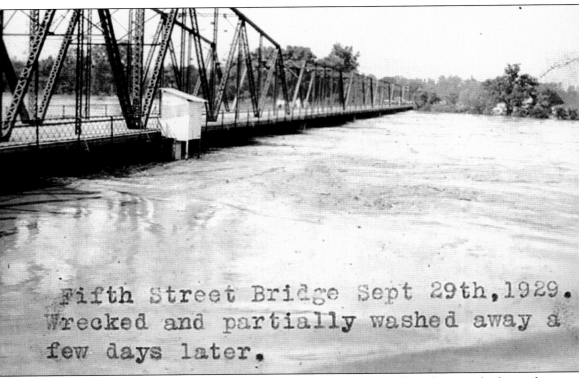

The Savannah River reached great depths in September 1929. This photograph shows the water reaching the Fifth Street Bridge. The bridge was partially washed away a few days later. Reported in the October 9 *Augusta Chronicle*, this problem led to a conference to build an "all-weather" permanent bridge across the Savannah River.

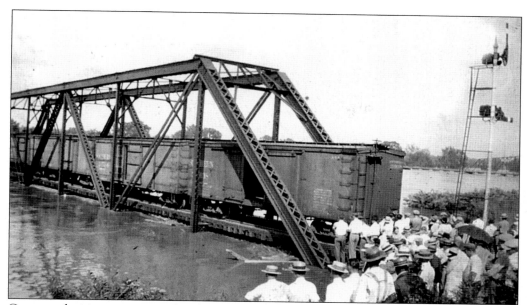

Concerned citizens positioned railroad cars on the Southern Railroad Bridge to keep the floodwater from washing it away. During the 1929 flood, the North Augusta Bridge closed when the wooden approach on the South Carolina side was damaged. The North Augusta Bridge remained closed for two weeks.

This photograph provides a rare look at Sand Bar Ferry Road. The levee is on the left. The flood caused a minor breach in the levee, five miles below Augusta.

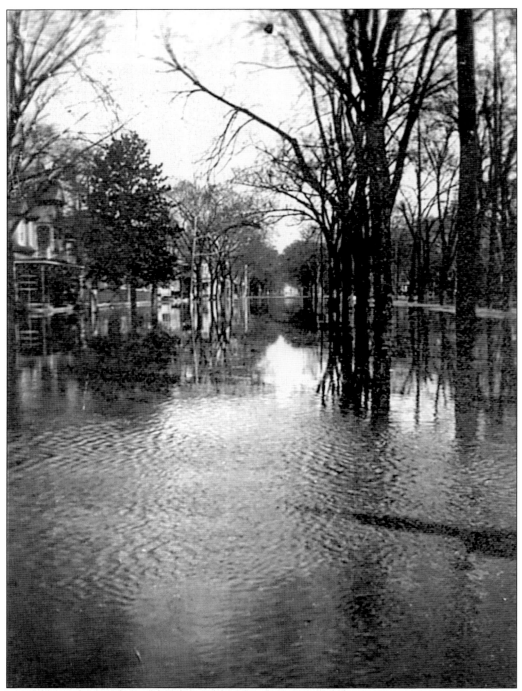

This postcard depicts floodwater covering upper Greene Street. Refugees thronged to tourist hotels. The October 3, 1929 *Augusta Chronicle* reported that approximately 1,000 refugees took up residence at the Forrest Ricker Hotel and the Bon-Air Vanderbilt Hotel. People also huddled in the courthouse.

Eight

Snow in Augusta

Many people may not view snow and ice as threats or disasters. However, in the climate of the South, snow and ice can bring life to a standstill. In December 1886, temperatures dropped to six degrees below zero. The arctic-like conditions froze all water. The fountains along Broad Street froze, the Augusta Canal froze over, and even the Savannah River froze. Many Augustans braved the subzero temperatures to view this historic occurrence. Then again, in 1917, temperatures dropped and an inch of snow blanketed Augusta. It was not so much the snow and ice, but the freezing temperatures that caused hardship. Many poor people did not have sufficient clothing or heat to withstand the severe weather.

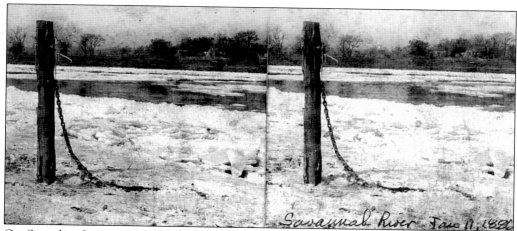

On Saturday, January 9, 1886, the temperatures fell drastically. Cold weather iced over the Savannah River. The canal froze over and forced all of the factories to shut when ice clogged up the water wheels and froze the machinery. Many people suffered from the extremely cold temperatures. Citizens contributed money, food, and wood to those in need. This stereo view of the river was taken January 11, 1886, by W.L. Cormany, located at 712 Broad Street. (Courtesy of Joseph M. Lee III.)

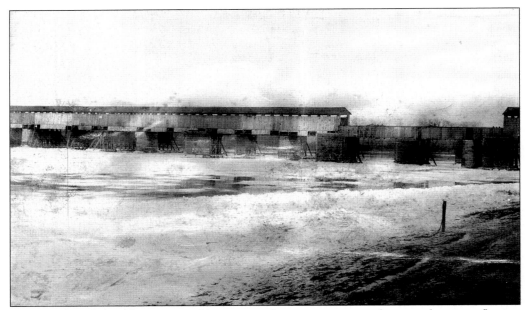

Many predicted that the river would retain ice for quite some time because the water flowing into the Savannah River came from colder areas. This photograph shows the entire expanse of the river covered with ice. The South Carolina-Georgia Railroad Bridge and the Centre Street Bridge are seen in the background. A few days later, the *Augusta Chronicle* wrote about Patrick H. Hutchins, an engineer of the Street Railroad Co. Hutchins decided he would be the first and only man to walk across the river. Others, though not as daring as Mr. Hutchins, climbed down the pier of the South Carolina bridge.

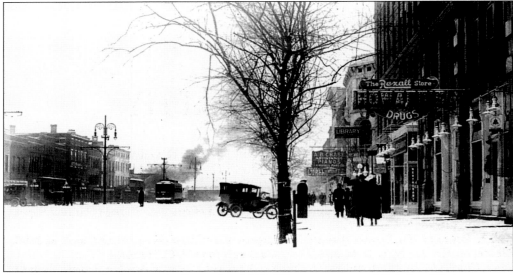

A cold wave struck Augusta in December 1917. The temperature fell below 20 degrees and shortly after midnight on December 30, snow began to fall. This cold weather carried over into the New Year. This postcard provides a view down the 700 block of Broad Street blanketed with snow on December 31. The postcard was published by Farrar's of Augusta. (Courtesy of Joseph M. Lee III.)

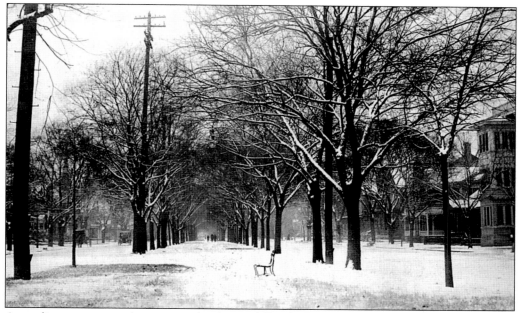

According to reports, almost an inch of snow fell—the heaviest since 1914. The thermometer never rose above 24 degrees. The weather was so cold that it damaged water pipes. This postcard was sent to Lola Meskall in Pennsylvania. The message reads, "Here is a slight idea of the winter's here; nothing compared to the North, is it?" The image is looking down Greene Street. On the right, at the northeast corner, are the Shirley Apartments. These are now the Cobb House Apartments. (Courtesy of Joseph M. Lee III.)

BIBLIOGRAPHY

Augusta Chronicle and Sentinel. February 8–10, 1878.

Augusta Chronicle. January 10–14, 1886; June 8–July 20, 1899; November 27, 1899; December 10, 1899; August 30–September 5, 1908; March 17–18, 1912; March 16–18, 1913; December 29, 1917–January 2, 1918; September 28–30, 1929, October 2–13, 1929.

Augusta Unit Federal Writers Project in Georgia. *American Guide Series, Augusta.* Works Progress Administration, sponsored by City Council of Augusta. Tidwell Printing Supply Co.: Augusta, Georgia, 1938.

Cashin, Edward J. *The Story of Augusta.* The Reprint Co.: Spartanburg, South Carolina, 1996.

Fire Report No. 278 by H. S. Jenkins, D. L. Wardroper, and H. C. Hutson.

Jones, Charles C. Jr., LL.D, and Salem Dutcher. *Memorial History of Augusta Georgia, Georgia Heritage Series No. 3.* D. Mason and Co.: Syracuse, New York, 1890.

The Merchants and Manufacturers Association of Augusta, Georgia. Compiled by George A. Kent, 1915. "Augusta: A City of Opportunities."

Southeastern Underwriters Association. *Special Report on Conflagration, March 22 and 23, 1916, Augusta, Georgia, Investigation and Report Made March 24 to April 6, 1916.*

INDEX